IMPRESSIONISM
ITS FORERUNNERS
AND INFLUENCES

IMPRESSIONISM
ITS FORERUNNERS AND INFLUENCES

General Editor
Francesco Abbate

Translated by
W. J. Strachan
Chevalier des Artes et Lettres

Octopus Books

London · New York · Sydney · Hong Kong

English version first published 1972 by
Octopus Books Limited
59 Grosvenor Street, London W1
Translation © 1972 Octopus Books Limited

Distributed in Australia by
Angus & Robertson (Publishers) Pty Ltd
102 Glover Street, Cremorne, Sydney

ISBN 7064 0069 0

Originally published in Italian by
Fratelli Fabbri Editore
© 1966 Fratelli Fabbri Editore, Milan

Printed in Italy by Fratelli Fabbri Editore

CONTENTS

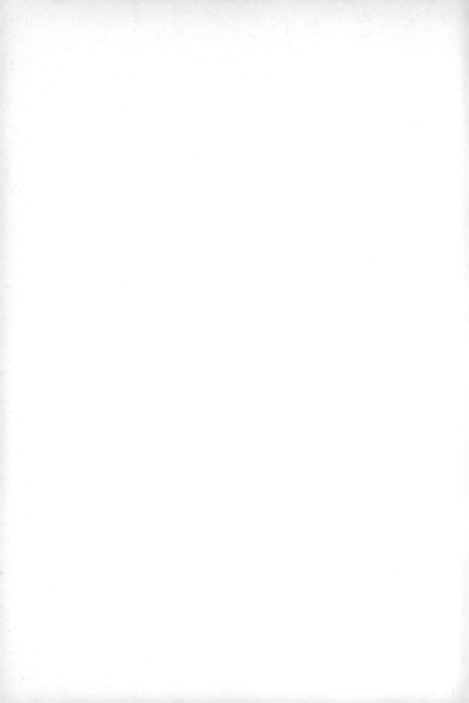

FORERUNNERS AND INFLUENCES

Throughout the whole of the nineteenth century France maintained a leading role in European art, especially in the field of painting. It is not difficult, as the century proceeds, to distinguish a central thread that develops logically from the romanticism of Delacroix through the naturalism of Corot, the Barbizon School and Courbet, and makes a final link with Impressionism. But alongside these major movements, and before Impressionism, there were episodes of a different nature, not part of conventional Romanticism. In France, Germany and England an original movement began, the precedents for which can perhaps be found in the activities of men like Blake and Fuseli; later it was resumed by the Symbolist artists at the close of the century. The chief exponents of the movement, which except in the case of the English Pre-Raphaelites was led by individuals rather than groups, were the French painters Puvis de Chavannes and Moreau, the German Von Marées, the Swiss Böcklin, and the Englishmen Dante Gabriel Rossetti and Burne-Jones – along with the

other Pre-Raphaelites. Their vision shared a common element: the rejection of a realism devoted to the faithful interpretation of outward appearance that dominated contemporary painting; they wanted to express in their art an inward spirituality through the symbolic values of the subjects represented. Their creed might be collectively expressed in the words of one of their number, Gustave Moreau: 'I do not believe in what I touch and what I see but I believe in what I do not see and what I feel.' Puvis de Chavannes' vast culture and refined sensibility led him to seek his own truth outside the experiences of his masters and contemporaries – even though they were Delacroix and Chassériau; absorbed in his dream of a world of spiritual harmony, he mistrusted the external appearance of reality in that he did not believe in the value of models that existed, almost, to be passively imitated. To give substance to his vision, he put his faith in a language of his own, based on compounded and simplified masses, illuminated by an unnatural light. In his murals, executed in Paris and various provincial centres, his figures have a strange nobility, no longer defined by precise contours, but sketched out in a scheme of planes and areas of flat colour. The starting-point in nature is subordinated to the allegorical significance that the artist imposes on the image. This tendency led to the idiom evolved by Gauguin and Emile Bernard.

A sympathiser with Puvis de Chavannes in his love for pure form – as distinct from naturalistic fidelity – and which he intended as an expression of lofty spiritual values, the German Hans von Marées con-

1 *Pierre Puvis de Chavannes (1824–98) : The Source. Musée des Beaux-Arts, Rheims.*

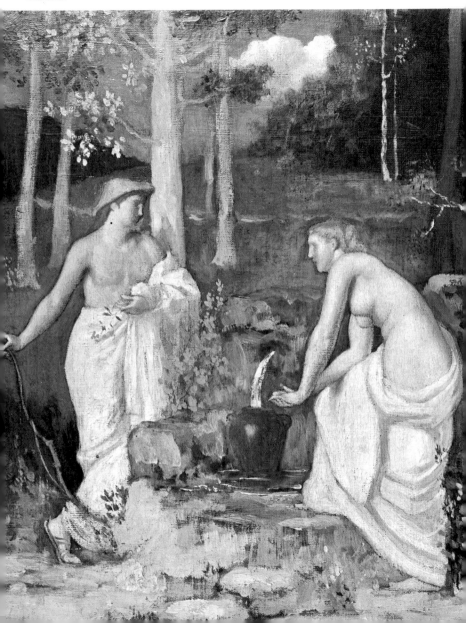

1 Pierre Puvis de Chavannes (1824–98): *The source.*
Musée des Beaux-Arts, Rheims.
The monumental simplification of the forms, the colour
painted in broad flat areas, the abstracted treatment of the
light are all indications of this artist's great originality.

2 Pierre Puvis de Chavannes (1824–98): *Mary Magda-
lene at St Baume.* 1869. Rijkmuseum Kröller-Müller,
Otterlo.
Puvis de Chavannes' compositions must have seemed mere
sketches to his contemporaries, whereas to him they
represented an ideal world into which he escaped from the
meanness of everyday life.

3 Hans von Marées (1837–87): *Diana bathing :* Bayer-
ische Staatsgemäldesammlungen, Munich.
Hans von Marées considered that painting should be a
vehicle for representing the rhythms and harmonies of
life, free from more immediate aims.

4 Hans von Márees (1837–87): *Three youths under the
orange trees.* Bayerische Staatsgemäldesammlungen,
Munich.
In von Marées' work the human figure, nude in most
cases, appears in a landscape setting: the natural scene is
limited to a clump of trees or rocks.

5 Anselm Feuerbach (1829–80): *Iphigenia.* Hessisches
Landesmuseum, Darmstadt.
Greek heroines are reborn in Feuerbach's pictures, in
solemn poses and eveloped in flowering robes.

6 Hans Thoma (1839–1924): *Landscape on the Rhine.*
1888. Staatsgalerie, Stuttgart.
In Hans Thoma the idealism of so much contemporary
painting is converted into something warmer and more
immediate – drawn from the living world about him.

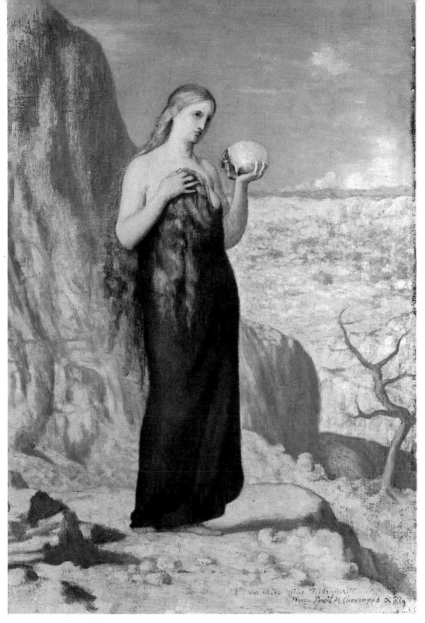

2 *Pierre Puvis de Chavannes (1824–98) : Mary Magdalene at St Baume.*
1869. Rijksmuseum Kröller-Müller, Otterlo.

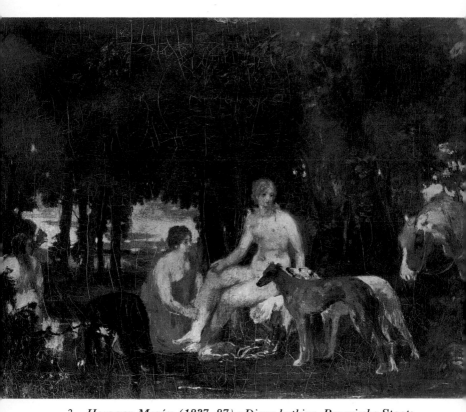

3 *Hans von Marées (1837–87) : Diana bathing. Bayerische Staats-gemäldesammlungen, Munich.*

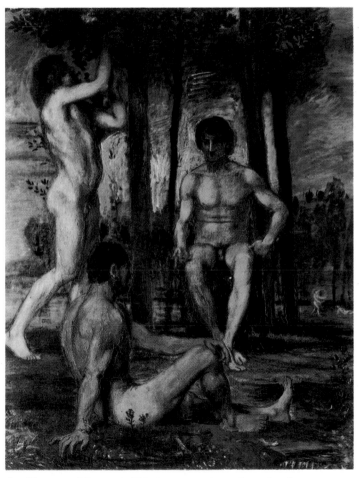

4 *Hans von Marées (1837–87) : Three youths under the orange-trees. Bayerische Staatsgemäldesammlungen, Munich.*

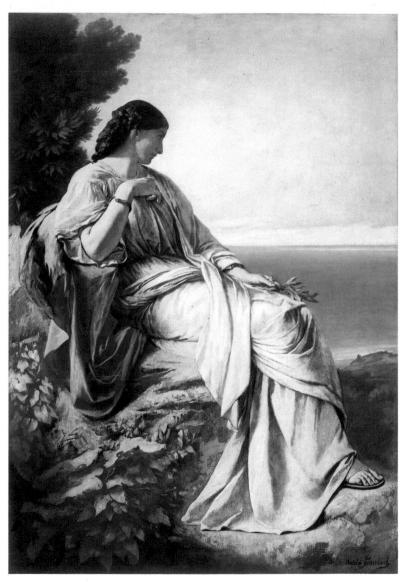

5 *Anselm Feuerbach (1829–80): Iphigenia. Hessisches Landesmuseum, Darmstadt.*

14

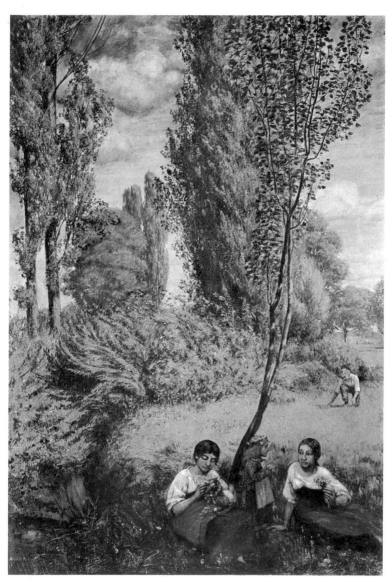

6 *Hans Thoma (1839–1924) : Landscape on the Rhine. 1888.*
Staatsgalerie, Stuttgart.

sistently chose to paint human figures in a landscape setting. His preference was for the nude since the nude seemed better adapted to his pictorial ideal, which consisted in the representation of abstract concepts such as rhythm, harmony, balance and clarity in purely visual terms of line, form and colour. But despite his theories there is nothing ostentatiously programmatic in von Marées' painting; on the contrary, the sober and essential monumentality of his figures, composed in strict and calculated rhythms, acquires an extraordinarily expressive intensity, a concentrated power that underlines the artist's inspiration. His period in Rome, while providing him with inspiration and opportunities for meditation on the fascinating Classical world, did not lead him, like the Nazarenes before him, to an imitation of the ancients. Such, however, was the stand taken by Feuerbach, who lagged behind contemporary culture and in his cold and melancholy pictures of young women, turned back nostalgically to the purity of classical forms. Other painters, more inclined towards naturalism, reacted against this type of culture that looked back to the past and was filled with historical and literary evocations. Adolph von Menzel, for one, was endowed with a genuine poetic vein and expressed it in bright landscapes and romantic settings, even if his results were not very consistent; Wilhelm Leibl, following Courbet's example, dedicated himself to realistic if crude studies of peasant life; Hans Thoma, a sporadic artist, sometimes – especially in his vast landscapes – struck notes of sincere lyrical emotion.

But the most famous name in contemporary German

painting is that of Arnold Böcklin, Swiss by birth but who soon migrated to Germany. Like the French painter, Moreau, he took the rejection of reality to its logical extreme in favour of an imaginative inwardness expressed in symbolism as already foreshadowed·in Puvis de Chavannes and von Marées. His world is that of the haunted imagination, peopled by myths and monsters that echo his own anxieties. Settled later in Rome, he imbibed ancient legends and myths and extracted from them a chaotic repertory of images to clothe his visions. An irresistible creative impulse lies behind these compositions, which are then frozen in a surprisingly detailed and minutely calculated execution. It is as if he wanted to give an objective consistency to his disturbing fantasies, confronting us with a world where madness and reason join hands.

Unmistakeable similarities exist between Böcklin and Gustave Moreau; both were visionary spirits, endowed with fertile imaginations, but the latter's painting has none of Böcklin's frozen objectivity, and his canvas preserves intact the confusions of passions that disturb his mind. In fact the whole repertory of Decadence, the mystic and erotic yearning, the obsession with damnation and eternity, the excitement of the senses and the elevation of the spirit all find a place in Moreau's vision. And his means of expression are in perfect harmony with its demands: his paintings are illuminated with an incandescent glow, the bright colours have the exquisite quality of oriental gems, a sinuous line quivers through his sensually languid or despairingly heroic figures. If there were no precedents to Moreau's painting, his legacy was to be taken over

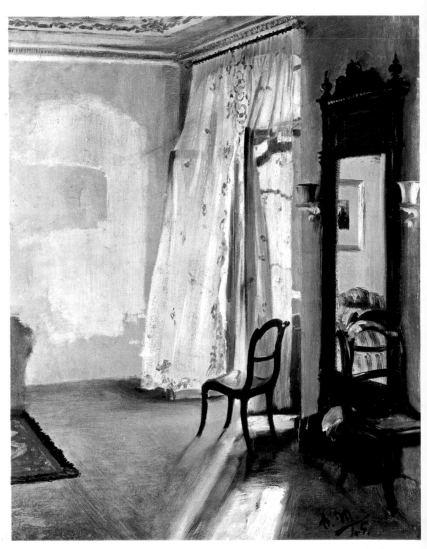

7 *Adolph von Menzel (1815–1905). The bedroom with the balcony. 1845.*
Nationalgalerie, Staatliche Museen, Berlin.

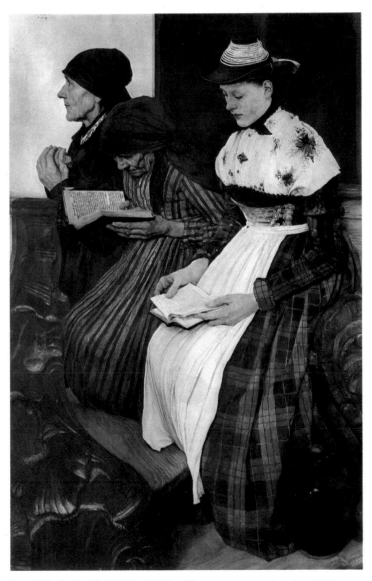

8 *Wilhelm Leibl (1844–1900) : Three women in church. c 1881.*
Kunsthalle, Hamburg.

7 Adolph von Menzel (1815–1905): *The bedroom with the balcony*. 1945. Nationalgalerie, Staatliche Museen, Berlin. This canvas contains realistic and impressionistic features: a shimmering light envelops every object, sharpening contrasts and heightening the viewer's interest in an otherwise ordinary scene.

8 Wilhelm Leibl (1844–1900): *Three women in church*. c 1881. Kunsthalle, Hamburg.
In contrast to the idealized painting of Feuerbach and von Marées, Leibl was one of a group of German artists inspired by everyday reality; Leibl's own realism was largely confined to peasant scenes.

9 Arnold Böcklin (1827–1901): *Youth and girl with flowers*. 1866. Kunsthaus, Zurich.
This is one of the painter's most serene works: for once he seems to have abandoned himself wholly to the joy of painting, to the fresh haze of bright colours, drenched with light. The symbolism and mythological content typical of many of his works are here subjugated in a purely lyrical vision.

10 Gustave Moreau (1826–96): *Narcissus*. Musée Moreau, Paris.
Moreau explored the same ambiguous world of antique fantasy as Böcklin: the Swiss excelled in descriptive detail and Moreau devised a more personal style.

11 Gustave Moreau (1826–96): *The apparition*. 1876. Musée du Louvre, Paris.
Salome, the temptress and 'accursed Beauty' of Symbolist and Decadent art, is here transfixed by the apparition of the head of John the Baptist; Moreau's implacable heroine was widely taken up by writers as well as artists, enchanted by the painting's atmosphere of Byzantine richness and, at the same time, its anaemic colour.

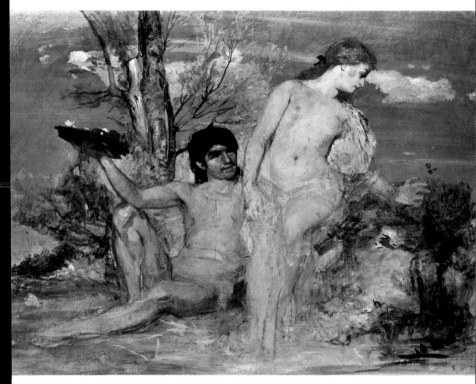

9 *Arnold Böcklin (1827–1901) : Youth and girl with flowers.*
1866. Kunsthaus, Zurich.

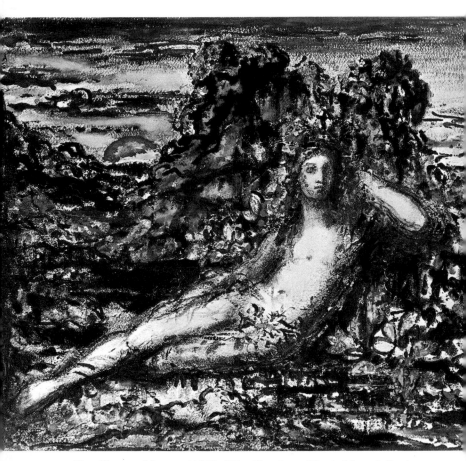

10 *Gustave Moreau (1826–96) : Narcissus. Musée Moreai, Paris.*

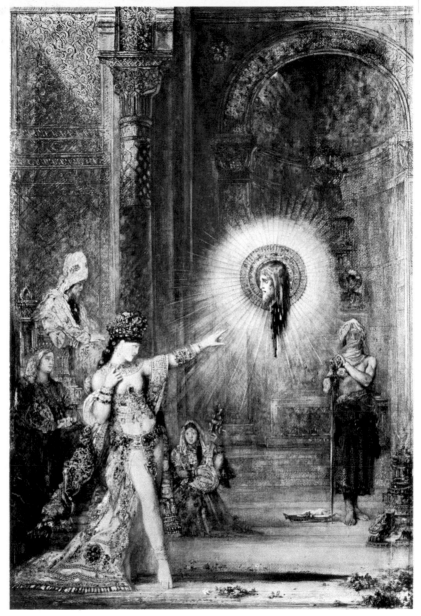

11 *Gustave Moreau (1826–96) : The apparition. 1876. Musée du
Louvre, Paris.*

by the *fin-de-siècle* Symbolists and prove decisive in the creation of Surrealism.

Towards the mid-century, in 1848 to be precise, the so-called Pre-Raphaelite Brotherhood was established round the writer and art-critic John Ruskin and embraced a group of young painters who were attracted to his ideas. Thanks to the Universal Exhibition of 1855 in Paris, they became known in France and were highly appreciated by many critics and artists, particularly Baudelaire. The Pre-Raphael-ites, as the name implies, aimed at restoring to art the purity and expressive nobility of Italian painting before Raphael, and restoring its social value as a stimulus and encouragement to high ideals. The theory, aimed at bringing art into the very heart of society, so that it became part of everyday life – a view shared later by the creators of Art Nouveau – was variously interpreted by members of the Brotherhood. The most fascinating figure in the group was Dante Gabriel Rossetti, the son of an Italian immigrant, who early came under the influence of Ford Madox Brown and then attached himself to Holman Hunt and the teaching of Ruskin. In time he extended his activities beyond painting to book-illustration, stained-glass and a series of frescoes. He used reality merely as a means for expressing his own ideas, investing his pictures with symbolic and allegorical content; his popularity, however, is associated less with his complex intellectual notions than with the physical types he created – the frail and anxious girl, a mixture of innocence and sensuality, and the mature, languid and alluring figure inspired by Elizabeth

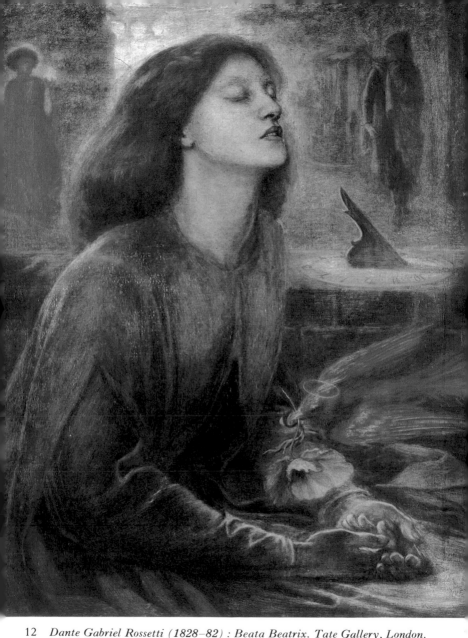

12 *Dante Gabriel Rossetti (1828–82) : Beata Beatrix. Tate Gallery, London.*

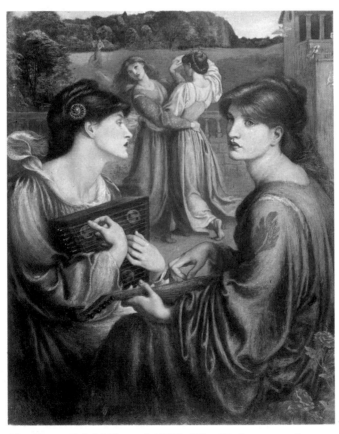

13 *Dante Gabriel Rossetti (1828–82) : The bower meadow.*
City Art Galleries, Manchester.

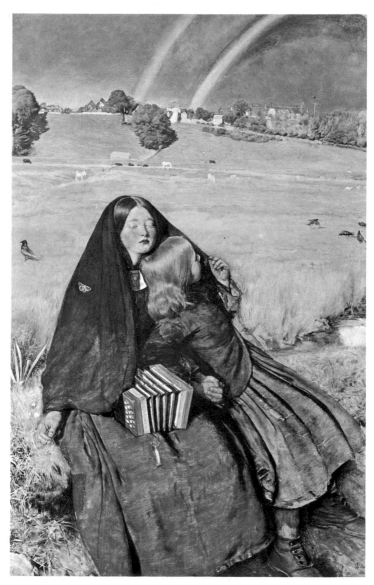

14 *John Everett Millais (1829–96) : The blind girl. Museum and Art Gallery, Birmingham.*

12 Dante Gabriel Rossetti (1828–82): *Beata Beatrix*.
Tate Gallery, London.
For Rossetti reality served merely as a vehicle for express-
ing the artist's anguish and hidden dreams; his colours
are intense and emotionally juxtaposed, and details are
bypassed in the search for evocative images that float in
an unreal setting.

13 Dante Gabriel Rossetti (1828–82): *The bower
meadow*. City Art Galleries, Manchester.
A dreamlike atmosphere envelops these green-eyed,
ethereal women, creatures of unfulfilled yearning typical
of Rossetti and his enthusiasm for the world of medieval
romance.

14 John Everett Millais (1829–96): *The blind girl*. 1856.
Museum and Art Gallery, Birmingham.
Millais' pictures are characterized by an acute attention
to detail and the use of vibrant, sometimes harsh colour.

15 William Holman Hunt (1827–1910): *The shadow of
death*. City Art Galleries, Manchester.
Much of Holman Hunt's work was devoted to biblical
scenes, which he conveyed with a compulsive regard for
detail; this was sometimes achieved at the expense of
overall unity but evidently suited his stern didactic aims.

16 Edward Burne-Jones (1833–98): *The golden stairs*
(detail). Tate Gallery, London.
Burne-Jones was influenced by Rossetti and Ruskin;
from the former he developed the strange physical type
shown here in languide procession: the faces are mysteri-
ous, white, suggesting some internal damage suffered a
long time ago. 'Those bruised eyes,' wrote Octave
Mirbeau, 'are unique in art.'

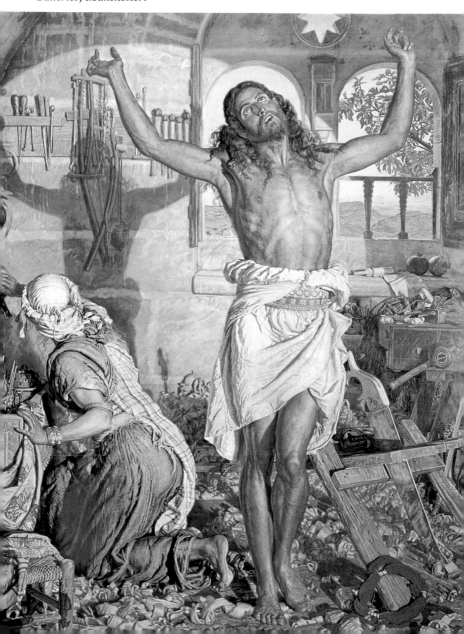

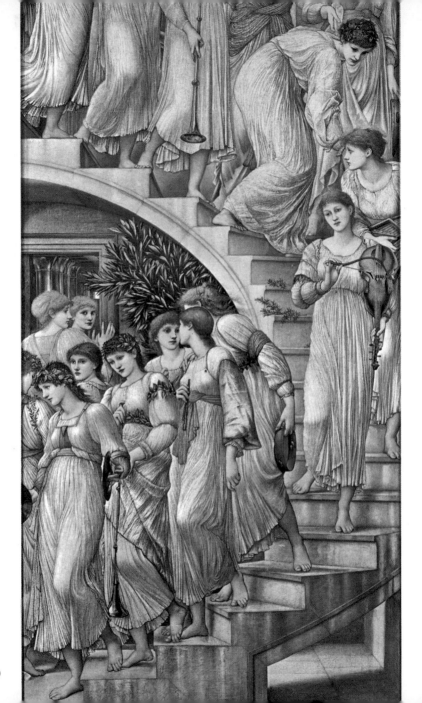

Siddall – that were to become prototypes of decadent taste.

More than Holman Hunt, whose painting is dominated by religious preoccupations and the desire to express a kind of mystical yearning, and more than John Everett Millais, Edward Burne-Jones, the youngest of the Pre-Raphaelites, was directly concerned with reality and human problems. In this he followed the lead given to him by Rossetti, and also put into practice the lessons he had learned from the Italian *quattrocento* painters. Not content with passive imitation, he exploited the elegance of their arabesques and the harmony of their forms. In a subtle language he reanimated mythology and legend, though his allusions to the secret truths of the soul remained clear. Like Burne-Jones he did not hesitate to extend his activities to the applied arts, thus implementing the social purposes behind the Pre-Raphaelite movement.

In 1874 in Paris, on the premises of the photographer Nadar, an exhibition was being set up of young painters who, intolerant of the reactionary and academic climate in which official painting was stagnating, sought other outlets. Edmond Renoir, the brother of one of their number, was charged with the preparation of the catalogue and in view of the monotony of the labels stuck on the paintings, described a canvas by Monet as 'Impression: Sunrise'. Next day a critic of *Charivari* spoke ironically of the event as the 'exhibition of the impressionists'. That was the origin of a term destined to become famous throughout the world. Monet,

16 *Edward Burne-Jones (1833–98) : The golden stairs (detail).*
Tate Gallery, London.

17 *Henri Fantin-Latour (1836–1904) : Still life. 1874.*
Konstmuseum, Gothenburg.

18 *Johan Barthold Jongkind (1819–91) : L'auberge des Balbins. 1869. Petit Palais, Paris.*

17 Henri Fantin-Latour (1836–1904): *Still Life*. 1874. Konstmuseum, Gothenburg, Sweden.
In Latour's still life reality is captured with a naturalness and sensibility sometimes reminiscent of Chardin's best works.

18 Johan Barthold Jongkind (1819–91): *L'auberge des Balbins*. 1869. Petit Palais, Paris.
Jongkind's work was admired by Baudelaire and other French Impressionists; he was not an open-air painter and preferred to work in the studio from sketches.

19 James McNeil Whistler (1834–1903): *Nocturne in blue and gold, Old Battersea Bridge. c* 1870. Tate Gallery, London.
Whistler, influenced at an early stage by Courbet and later by the flat spaces of Japanese prints, sought out the most refined harmonies for his *Nocturne* series.

20 Eugène Boudin (1824–98): *The Empress Eugénie on the beach at Trouville*. 1863. Art Gallery, Glasgow; Burrell Collection.
Boudin's figures, a series of squat-looking, triangular shapes, bustle along beneath a huge sky, their heads just breaking the line of the horizon. Seascapes were among Boudin's favourite subjects: for him the important thing was to paint '*en plein air*' in contact with nature since 'everything that is painted *sur le motif* has a power, strength and liveliness of touch not to be found in the studio.'

21 Eugène Boudin (1824–98): *Bordeaux harbour*. National Gallery of Scotland, Edinburgh.
This lively port scene is crammed with detail and set beneath a pale, open sky, the two halves of the painting being united by the twin zones of sky and water, each seeming to reflect qualities belonging to the other.

19 *James McNeill Whistler (1834–1903) : Nocturne in blue gold, Old Battersea Bridge. c 1870. Tate Gallery, London.*

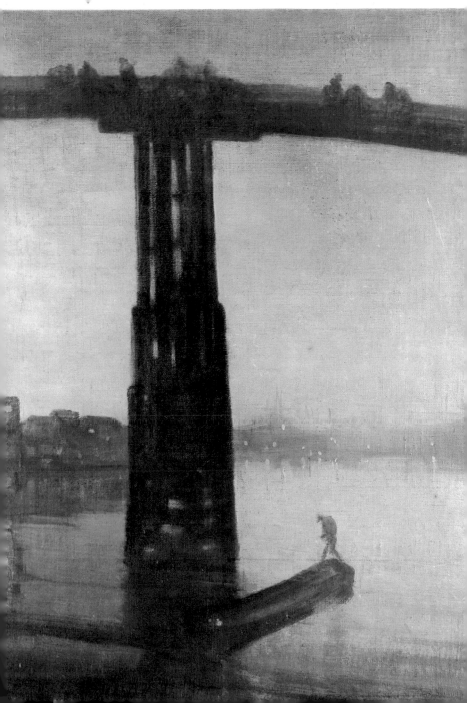

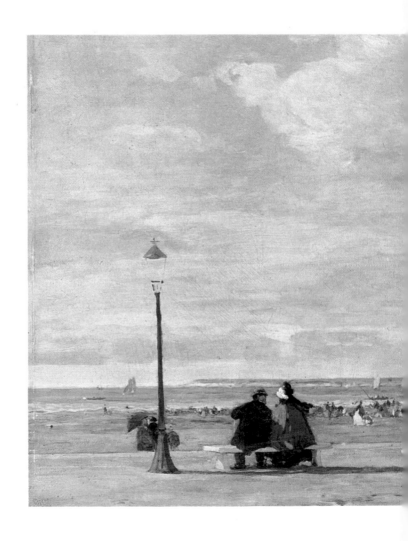

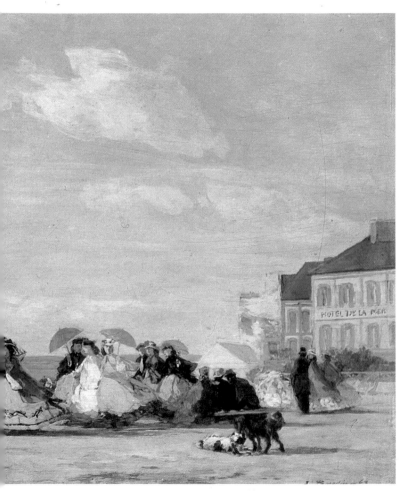

20　*Eugène Boudin (1824–98) : The Empress Eugénie on the beach at Trouville. 1863. Art Gallery, Glasgow.*

21 *Eugène Boudin (1824–98) : Bordeaux harbour. National Gallery of Scotland, Edinburgh.*

Renoir, Sisley, Pissarro, flanked by the outstanding personalities of Manet and Degas, are the great figures of the movement. Arising from opposition and difficulties of every kind, maligned by public and critics alike, it is yet the richest, most complete and the most original and extraordinary experiment in representational art of the nineteenth century. The novelty of Impressionism lay not only in the style and technique adopted in painting but in the artist's attitude to the world and the natural sights that confronted him. For the Impressionist there were no preconceived, cultural or literary formulas to intervene between his eyes and the living reality; he felt free to exploit every aspect of nature as it struck him, and filtered only through his emotions. The balance between the visual truth of things and their lyrical content was Impressionism's greatest achievement; while their awareness of their own freedom, the autonomy they had gained *vis-à-vis* their subjects generated a sheer joy in painting, a creative enthusiasm that became an impassioned hymn to the inexhaustible and ever-varied beauty of the earth. *Plein-air* painting was the great discovery of the Impressionists. Possessed as though by fever they spent their days and sometimes their nights in the open-air, excited by the constantly changing lights and colours in the water, in the sky, in flowers, in the human face. In their work they celebrated the brilliance of these lights, their rich colours, and the magic of their luminous reflections. The atmospheric tableaux of a painter like Daubigny, whose landscapes are suspended in time, were supplanted by an irresistible flow of life in

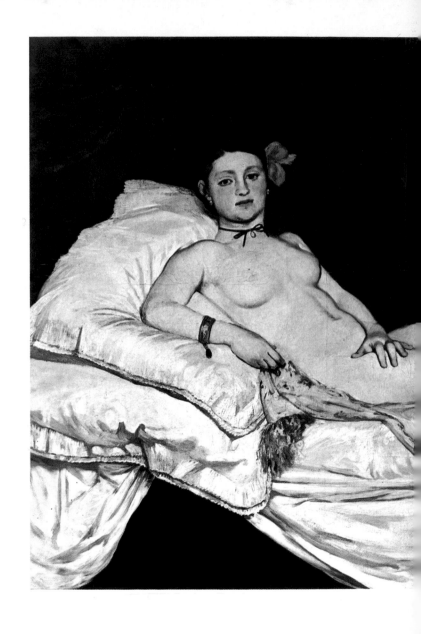

22 *Edouard Manet (1832–83) : Olympia. 1863. Musée du Louvre, Paris.*

22 Edouard Manet (1832–83): *Olympia*. 1863. Musée du Louvre, Paris.
Edouard Manet constructed this realist interpretation of an ancient theme in flat colour-areas, arranging light colours on light, dark on dark and introducing rare splashes of colour here and there – in the bunch of flowers and in one or two isolated patches.

23 Edouard Manet (1832–83): *Self-portrait with palette*. 1879. Collection Mr. and Mrs. John L. Loeb, New York.
Manet has here kept his range of tones almost to a minimum; by similarly restricting himself to a few broad brush-strokes in his treatment of the body he has produced a captivating portrait, at first glance a rapid sketch, on closer inspection a radiant study, perceptive and filled with light.

24 Edouard Manet (1832–83): *A bar at the Folies-Bergère*. 1882. Courtauld Institute Galleries, London.
This is one of the artist's last major works, completed a year before his death; in it he combines with great mastery his personal method of separating the canvas into zones of light and dark colour and a gayer, more Impressionist touch and use of colour.

25 Edouard Manet (1832–83): *Rue Mosnier decked with flags*. 1878. National Gallery of Art, Washington, DC; collection Mr. and Mrs. Paul Mellon.
This bright study is one of five painted by Manet during the celebrations commemorating the success of the Paris World's Fair. The style is sketchy and more immediate than the previous examples, according more with Manet's late conversion to open-air painting.

23 *Edouard Manet (1832–83) : Self-portrait with palet* *1878. Mr. and Mrs. John L. Loeb Collection, New York.*

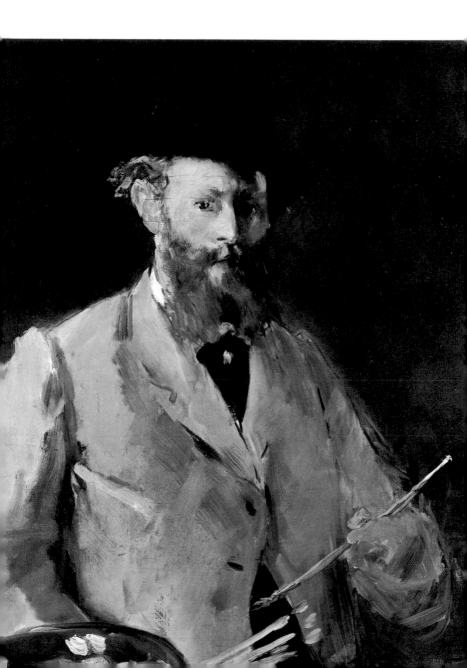

24 *Edouard Manet
(1832–83)* : *A bar at the
Folies-Bergère. 1882.
Courtauld Institute
Galleries, London.*

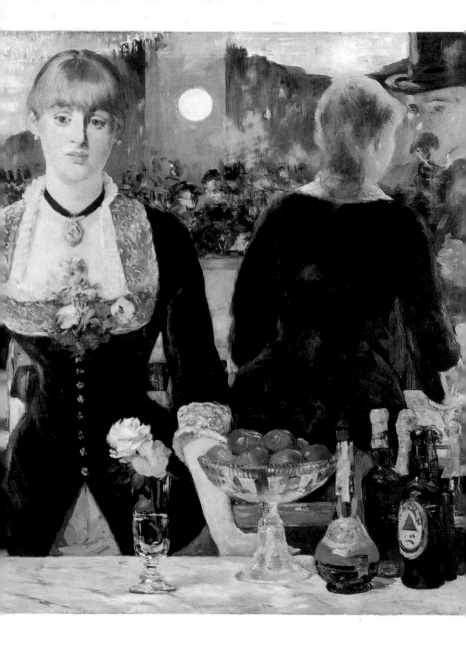

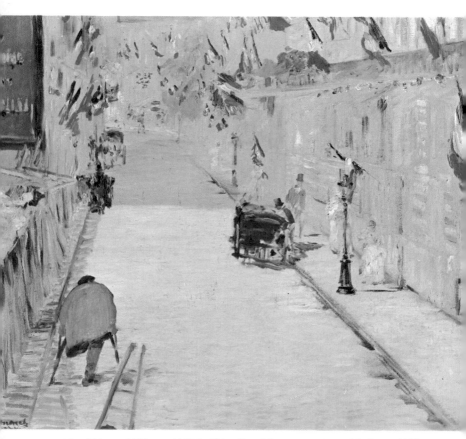

25 *Edouard Manet (1832–83) : Rue Mosnier decked with flags. 1878.*
National Gallery of Art, Washington, DC.

Impressionist work. The contemplative serenity of Corot gives way to the immediacy of a direct relationship with nature; the fidelity of Courbet's objectively viewed scenes is replaced by a more subjective attitude – a simultaneously visual and emotional interpretation of nature and people. This was to some extent the revolutionary weapon that set the new painters apart from all previous experiments and made them triumphant originators of a new era in art. In some measure it can be said that there were links with the past, through certain painters who though sincere were undoubtedly of more modest ability. Thus men like Jongkind and Boudin can be considered as their immediate precursors.

Fantin-Latour and the American, Whistler, were among the young men who, like Manet, were enthusiastic admirers of Courbet's work when it was shown in the Pavillon du Réalisme in 1855. The robust naturalism of the Master of Ornans exercised a powerful influence on them and led them to approach reality with immediacy, in a manner not without its emotional side. Thus Fantin-Latour, a sensitive and subtle artist, succeeds in imparting a lyrical feeling to his tranquil interiors, in which figures emerge from the shadows in dignified, unaffected attitudes. His best efforts, however, were centred round his experiments with still-lifes, simple bunches of flowers or assembled objects, realized with exquisite formal counterpoise and enlivened with subtle colour imbued with poetic feeling.

For James McNeil Whistler, a refined and cultured man, open to every intellectual adventure, art was

above all a matter of taste. Whilst accepting Courbet's view with some reserve and falling under the discreet but no less intense fascination of Fantin's painting, he maintained in his pictures a nice balance based on exquisite formal elegance and a skilled use of subdued tonal harmonies developed from a single colour. His early portraits are painted in wonderful harmonies of grey; then, after his discovery of Japanese prints, he tended to restrict himself to variations in tones of white. Gradually he moved away from reality, and his paintings became to some extent pretexts for lyrical experiments in light and colour.

The vocation of the Dutch painter Jongkind, whose restless and troubled life was spent between Paris and the Normandy coast, was very different. Likewise a romantic spirit, obsessed by the landscape tradition of his native land, he found in nature echoes of his own anxieties. More so than in his oil paintings, his vision is expressed with great clarity in his water colours; with a few swift touches he renders variations of light, the changing reflections in water, the outlines of distant hills.

Boudin – who was born at Honfleur, near Le Havre – also found his subjects in the picturesque aspects of his native coast. In his time he had no rival in the art of describing the merging of sea and sky according to the hour and season, also in his more animated scenes of beaches invaded by holiday-makers. The themes of his canvases were simple and he treated them with freshness and a belief in the continuity of everyday life. Eugène Boudin was a generous, modest man and kept aloof from the great Impressionist adventure,

but Manet was to learn from him, as well as from Jongkind, the first fundamental lesson which led him to realize his own personal artistic revolution. In 1863, on Napoleon III's orders, the Salon des Refusés was opened in Paris to house all the paintings refused by the official Salon. Among the exhibitors were Whistler, Fantin-Latour and Jongkind, but the picture that aroused the most vigorous reactions and the most lively controversy was Edouard Manet's *Le déjeuner sur l'herbe*. The thirty-one-year-old painter had already shown his talent in the years before, demonstrating his familiarity with such masters as Goya and Velasquez, and Courbet, a figure from his own time, and producing painting that was rich in vitality, luminous and exuberant in colour. His picture *Music in the Tuileries*, which slightly antedates *Le déjeuner*, further reveals his originality of composition and his fundamental preference for a realist approach. But if that painting had won approval, his *Déjeuner* alienated the organizers and made a great scandal. In this work, modelled on Giorgione's *Concert champêtre* and an engraving by Marc Antonio (Raimondi) after Raphael, Manet portrayed on the sunlit banks of the Seine two impeccably dressed gentlemen with a nude beside them while another nude is emerging from the river. It was a modern work, a masterpiece of composition and colour. The critics failed to comprehend the value of what they saw. The storm of indignation rose still higher on the appearance of *Olympia*, a female nude comparable to Titian's Urbino *Venus* or Goya's *Maja*, showing with what profound originality a modern could interpret

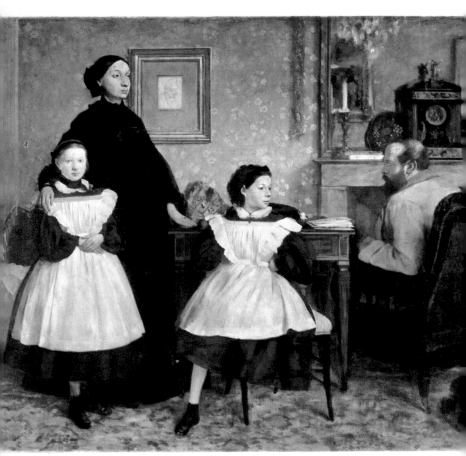

26 *Edgar Degas (1834–1917) : The Bellelli family. 1860–62. Musée du Louvre, Paris.*

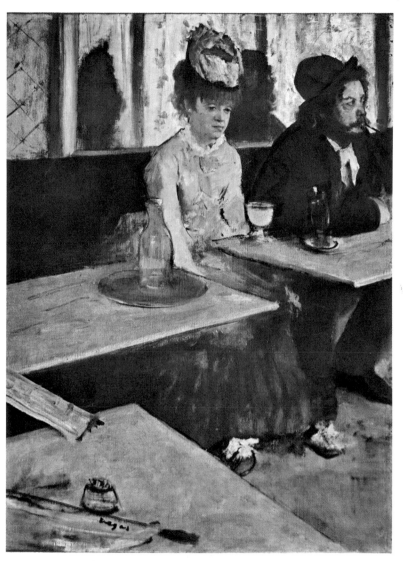

27 *Edgar Degas (1834–1917) : Absinthe. 1876. Musée du Louvre, Paris.*

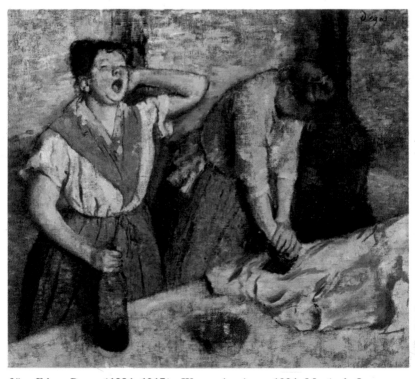

28 *Edgar Degas (1834–1917) : Women ironing. c 1884. Musée du Louvre,*
Paris.

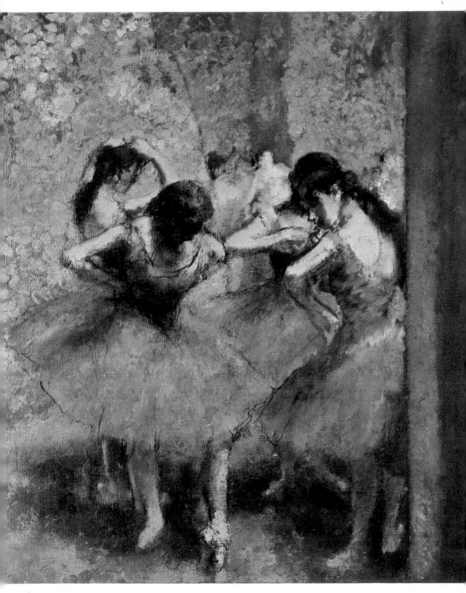

29 *Edgar Degas (1834–1917) : Dancers in blue. 1890. Musée du Louvre, Paris.*

26 Edgar Degas (1834–1917): *The Bellelli family*.
1860–2. Musée du Louvre, Paris.
Degas, at this period still in his twenties, set himself to
do 'portraits of people in natural and characteristic
attitudes, giving the same qualities of expression to their
faces as to their bodies.' The pose is formal and restrained,
but Degas' great qualities of draughtsmanship and poetic
insight are well in evidence.

27 Edgar Degas (1834–1917): *Absinthe*. 1876. Musée du
Louvre, Paris.
The zigzag movement of this composition is one of Degas'
most brilliant inventions: the effect he attains of depth
is extraordinarily telling.

28 Edgar Degas (1834–1917): *Women ironing*. *c* 1884.
Musée du Louvre, Paris.
This fine study of contrasted movement catches two
precise and typical moments in the working lives of the
laundresses.

29 Edgar Degas (1834–1917): *Dancers in blue*. 1890.
Musée du Louvre, Paris.
Many of Degas' developed works were inspired by the
world of ballet. In them he developed his penetrating
observation of gesture and pose.

30 Edgar Degas (1834–1917): *Ballerina*. Niedersäch-
sisches Landesmuseum, Hanover.
As a sculptor Degas was one of the most advanced artists
of his day: his figures have a lightness and buoyance that
was nevertheless as carefully worked out as the articulation
of his painted groups. 'No art,' wrote Degas, 'was ever less
spontaneous than mine.'

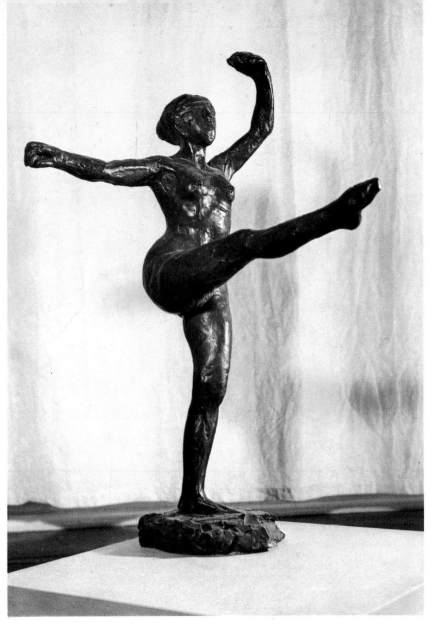

30 *Edgar Degas (1834–1917) : Ballerina. Niedersächsisches Landesmuseum, Hanover.*

the influences of the Old Masters. *Olympia* is executed in a skilfully assimilated language, with flat areas of colour, unusual effects of light on light and dark on dark, the result of which is a measured piece of fine painting. Later, Manet took account of the discoveries of Monet and the other young Impressionists and transferred his attention to landscape. The observations he made from life enriched his language still further, as we see in his final masterpiece *A bar at the Folies-Bergère.*

Edouard Manet and Edgar Degas were linked in a bond of love-hatred; both belonged to a cultured middle-class and moved in aristocratic and intellectual circles. Their activities took place on the fringe of Impressionism, since they were only partially involved in the great adventure iniated by Monet. Degas passed his artistic life in proud, withdrawn seclusion; he was the most mature and at the same time the most implacably objective of the great painters living in Paris in those years. Vocationally attracted to realistic painting after a profound study of the Old Masters, he turned his attention to a language capable of expressing reality in all its immediacy and complexity. His first important picture, *The Bellelli family*, painted in Florence, reveals a draughtsmanship of rare purity; there is a subtle harmony in both the colour and composition of this middle class interior. Back in Paris after a period in Italy, Degas became briefly interested in historical painting, which he then abandoned to devote himself wholly to the depiction of contemporary life: the magic and scintillating world of the theatre, the smoke-filled cafés, the outer suburbs of Paris

where the stark intimacy of the houses offered inexhaustible sources for his thirst for knowledge. He translated these subjects with an amazing insight, the difficulties of formal problems – for Degas persistently endeavoured to improve his technique – becoming somehow linked to his strange intuitive feeling for the truth about objects and people. His bold engravings after the model of Japanese prints, his dynamic and incisive drawing, the complicated cross-lighting that is a feature above all of his famous ballet scenes, are aspects that emphasize the forcefulness of his compositions. Nor are his small bronze figures of trotting horses or graceful ballerinas, expressed in dynamic rhythms of unsurpassed elegance, any less effective.

With Claude Monet we enter into the very heart of Impressionism. It was he, in fact, this humble painter who grew up in Le Havre, and learned from Jongkind and Boudin to contemplate vast natural landscapes, the changing lights in the water and the blue of the skies, who gave open-air painting its most natural expression and produced results so full of zest and promise for the future. Monet's eye dwelt with affection and joy on the thousand wonders in nature, he was the poet who transferred his visual impression on to the canvas with an excitement that was pure and fresh. In Paris, to which he went on Boudin's advice, Monet frequented Gleyre's studio where he enjoyed even more than the master's lessons the friendship of young fellow-pupils such as Bazille, Renoir and Sisley. And the enthusiasm with which they welcomed his new vision further confirmed him in his chosen path; together they went to Fontaine-

bleu, bathing themselves in air and light as they sought to give a new impetus to their creativity. Monet and his disciples were striving to capture the instantaneous quiver of life itself, the sudden lighting-up of green in a leaf caught by a ray of sunlight, the momentary reflections on a stretch of water that light and shadow chequer with their arabesques, the shudder that runs through a field of grass at midday. His landscapes are undoubtedly his most successful works, but he also placed the human figure in this same limpid atmospheric light – witness the fragment and sketch left to us of *Le dejeuner sur l'herbe,* his lost masterpiece. And it is amazing how, though faced with poverty and private troubles, Monet's genius managed to wrest from nature impressions of such unchanging and radiant happiness. Without making any concessions to current taste or the demands of contemporary criticism, Monet pursued his way, sustaining his role as guide to the Impressionist group and going on to organize their first exhibition in 1874. In the end his persistence and genius were rewarded: after 1890 his painting gained full official recognition, and in the new century when Monet, now an old man, retired to Giverny, painting only flowers and the water-lilies of his garden, all the painters of France regarded him as a great master.

Among all the artists who followed Monet on his peregrinations in the open air, the most faithful was certainly Auguste Renoir. For hours on end, day after day, they painted the same landscapes together and experimented in the same idiom. But if at first it is difficult to distinguish between their respective works,

the differences between the two personalities grew gradually more apparent, as Monet moved towards increasingly subtle visual investigations and Renoir came to enrich his warm, emotional vein. Renoir was in love with nature, the quivering tenderness of its forms and colours; for him painting meant uniting creation and creature in a single loving embrace. Educated by his study and contemplation of the masterpieces of the past, preserved in the Louvre, then won over by Courbet's vigorous naturalism, Renoir was next carried away by his discovery of open-air painting, to which Monet introduced him. His language as it matured became a song of life, joy, warm sunlight, the innocent stirrings of emotion. The whole of reality – from a vase of flowers to a little girl's face, from a dance or café scene to a young female body – vibrated for him with the same feeling of warm, conscious happiness. When, around 1884, Renoir decided after looking again at the great masters of the past to modify his idiom, to make his contours firmer and give his compositions greater structure, the imaginative side of his output was unchanged, and remained the same even in the final phase when his painting became wholly a matter of colour. Then it was colour that defined form and was the decisive element in his exhilarating world – a world that was as vigorous and personal as that seen in the last Titians and the best of Rubens.

Alongside the dominating personalities of Monet and Renoir were other artists who combined to create and intensify the climate of this exceptional period of European painting, sharing in the excitement of the

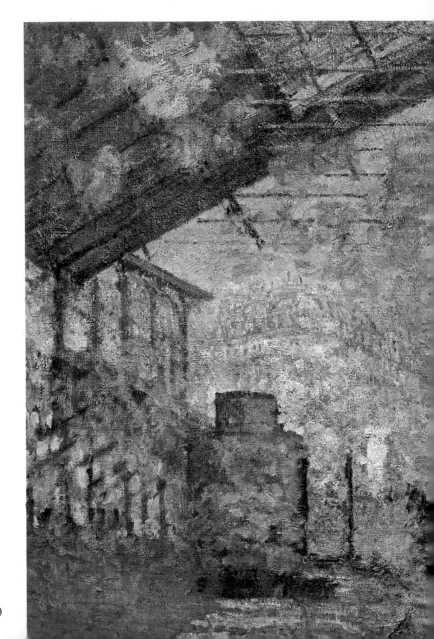

31 *Claude Monet (1840–1926) : Gare Saint-Lazare. 1877. Musée du
Louvre, Paris.*

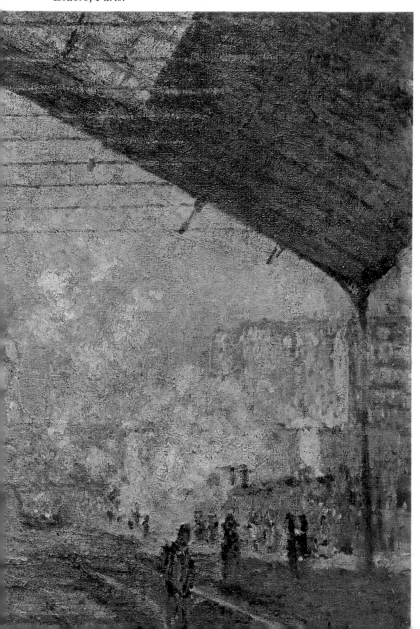

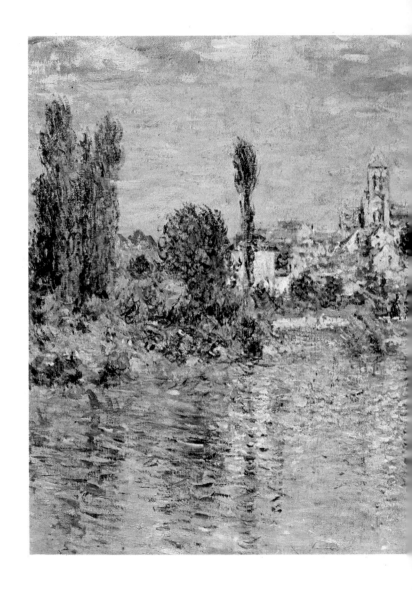

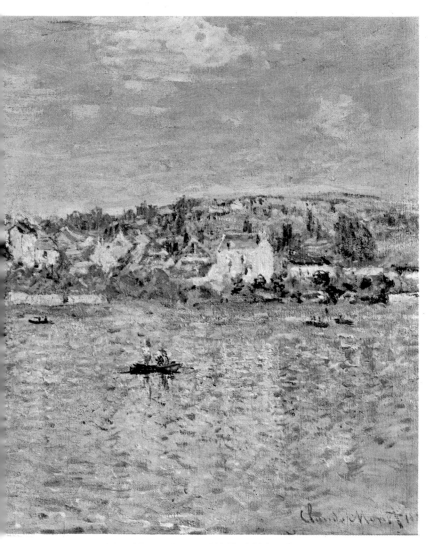

32 *Claude Monet (1840–1926) : Summer at Vétheuil. 1880.*
Metropolitan Museum of Art, New York.

31 Claude Monet (1840–1926): *Gare Saint-Lazare*. 1877. Musée du Louvre, Paris.
The crowds of travellers, the massive engines glimpsed in the smoky vault of the station offered a subject that fascinated the painter. He turned to it several times, always stimulated by a different 'impression'.

32 Claude Monet (1840–1926): *Summer at Vétheuil*. 1880. Metropolitan Museum of Art, New York.
The beauty of Monet's effervescent colour is here especially striking, the brush-strokes sparkle and a summer's day appears before our eyes. For the artist the period at Vétheuil was one of intense poverty and domestic tragedy, which he resolutely kept out of his painting.

33 Claude Monet (1840–1926): *The four poplars*. 1891. Metropolitan Museum of Art, New York; Mrs. H. O. Havemeyer bequest, 1929.
The stylized treatment of the trees, their reflected images and the vibrant light give an almost 'abstract' purity.

34 Claude Monet (1840–1926): *The Grand Canal, Venice*. 1908. Museum of Fine Arts, Boston, Mass; Alexander Cochrane Donation.
The shimmering light on the lagoon fascinated Monet and caused him to write: 'A pity I didn't come here when I was young! When I was full of daring!'

35 Claude Monet (1840–1926): *Water lilies. c* 1907. Bührle Collection, Zurich.
The water lilies in his garden at Giverny provided Monet with a subject for forty canvases between 1904 and 1908. 'These landscapes of water and reflections,' said Monet, 'have become my obsession.' At that time he had just recovered from another obsession – the Thames – which had been the inspiration of, up to 1904, more than a hundred paintings.

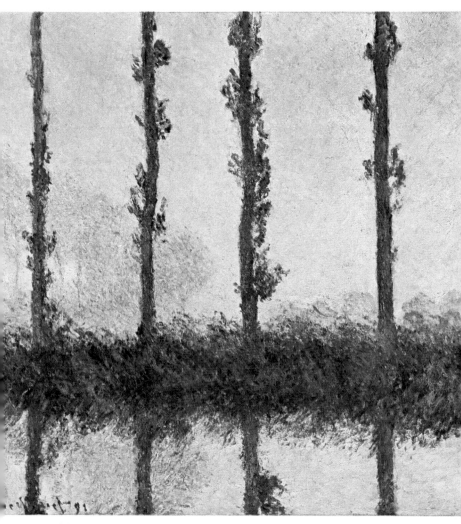

33 *Claude Monet (1840–1926) : The four poplars. 1891. Metropolitan Museum of Art, New York.*

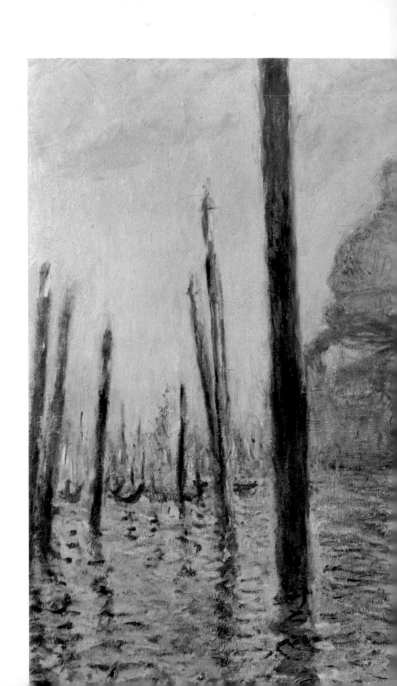

34 *Claude Monet (1840–1926) : The Grand Canal, Venice. 1908.*
Museum of Fine Arts, Boston, Mass.

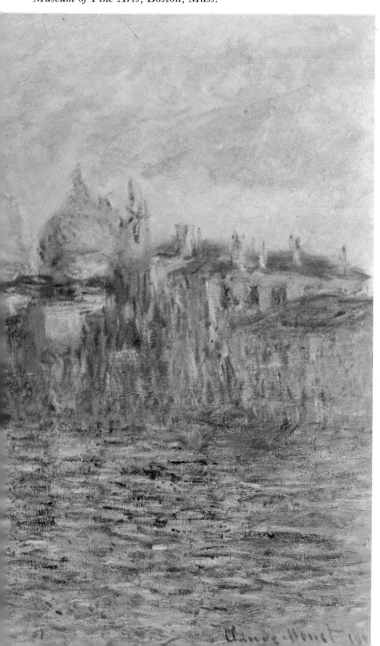

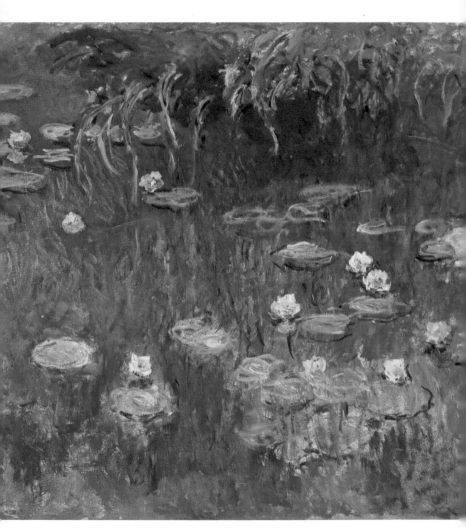

35 *Claude Monet (1840–1926) : Water lilies. c 1907. Bührle Collection,
Zurich.*

Impressionist adventure. It was above all from Monet that Alfred Sisley, born in France of English parents, learned his painting, but he owed something also to his early familiarity with the work of Corot and Daubigny. A pupil in Gleyre's *atelier*, as had been Monet and Renoir, he shared the experiments and enthusiasms of his new associates. The paths he followed, the subjects he sought in nature were the same as those that animated the canvases of Monet, Pissarro and other Impressionist painters. What distinguishes him from them all, however, and marks him out in the group is his delicate lyrical vein, his preference for calm, serene landscapes painted in subdued harmonies of colour. If Sisley's work lacks expressive fervour, his attempts to transfer the charm of a fragment of nature, visually analysed, on to his canvas are nevertheless informed with a touching delicacy. The views of Louveciennes, especially those conveying the magic silence after a snowfall, and the landscapes of Moret-sur-Loing, to which he finally retired, reveal a sincere and dedicated talent.

Landscapes predominate, too, in the paintings of Camille Pissarro, who came late to Impressionism after spending his formative period under Corot. He was also influenced by Millet, with whom he shared a deep love of the soil, and a concept of human dignity that went beyond social class; he was moved by life in the fields, the fruitful results of man's labour, in the country and on the farms. These elements remained in his work even after he made contact with Monet and decided to devote himself to the new Impressionist experiment. His paintings are solidly constructed,

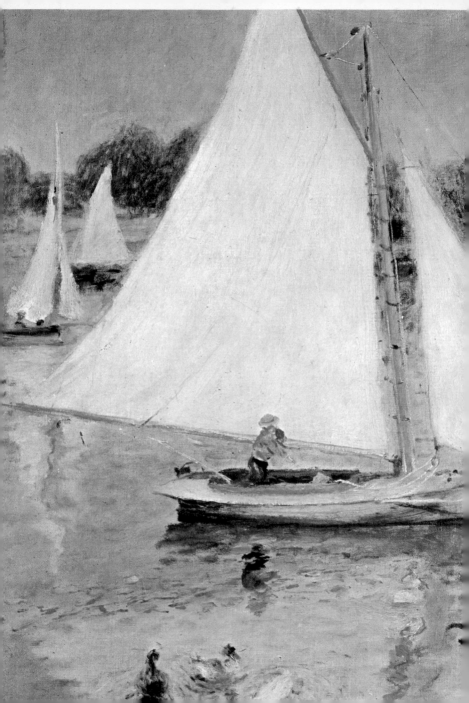

36 *Pierre-*
Auguste Renoir
(1841–1919):
Sailing-boats at
Argenteuil.
1873–4. Museum
of Art, Portland.

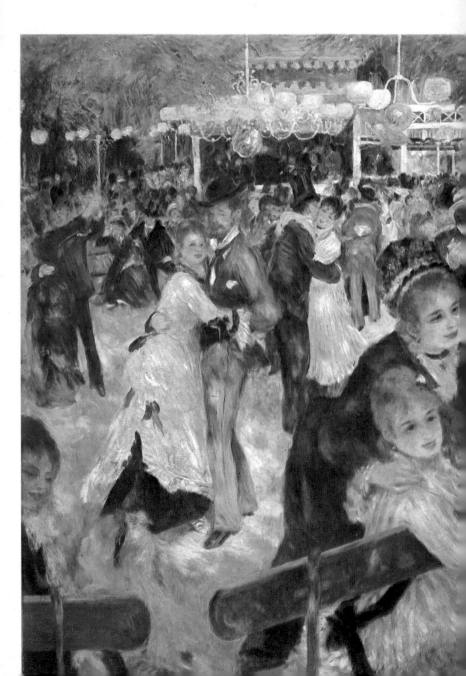

37 *Pierre-Auguste Renoir (1841–1919) : Le Moulin de la Galette.*
1876. Musée du Louvre, Paris.

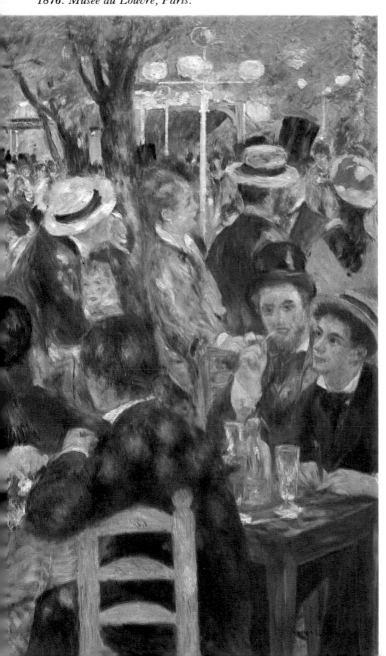

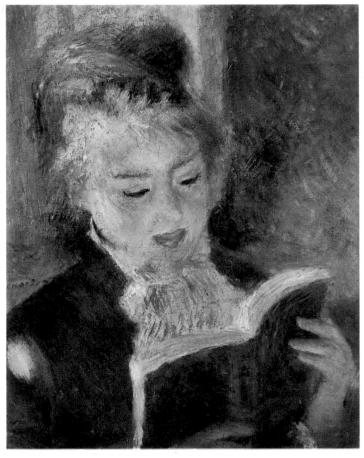

38 *Pierre-Auguste Renoir (1841–1919) : Woman reading. 1876.*
Musée du Louvre, Paris.

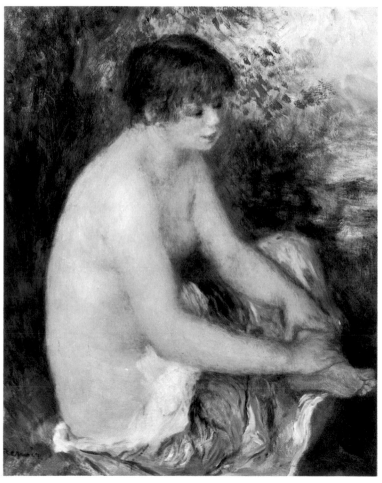

39 *Pierre-Auguste Renoir (1841–1919) : The bather. c 1880.*
Albright-Knox Art Gallery, Buffalo.

36 Pierre Auguste Renoir (1841 1919): *Sailing-boats at Argenteuil*. 1873–4. Museum of Art, Portland.
The tenderness that earlier artists – from Watteau to Boucher and Fragonard – had looked for in an idyllic, mythological world Renoir rediscovered in the contemporary world about him.

37 Pierre-Auguste Renoir (1841–1919): *Le Moulin de la Galette*. 1876. Musée du Louvre, Paris.
The years between 1870–80 were the most fruitful of Renoir's career: never had his palette been richer, never before had he succeeded in finding such perfect harmony between the living impression of things and the excitement they aroused in him.

38 Pierre-Auguste Renoir (1841–1919): *Woman reading*. 1876. Musée du Louvre, Paris.
Every aspect of contemporary life, from a woman reading to a girl on a swing, a girl bathing, a gay *bal* spring to life on Renoir's canvases with an extraordinary festive charm.

39 Pierre-Auguste Renoir (1841–1919): *The bather. c* 1880. Albright-Knox Art Gallery, Buffalo.
Nude woman bathing form one of Renoir's predominant themes: in such works the artist achieves symphonic effects with his well-rounded bodies, enveloping them in a luminous atmosphere.

40 Pierre-Auguste Renoir (1841–1919): *L'Estaque*. 1882. Museum of Fine Arts, Boston, Mass; Juliana Cheney Edwards Collection.
Violet shadows travel across the sun-bleached grass in this brilliant evocation of a gentle Mediterranean landscape.

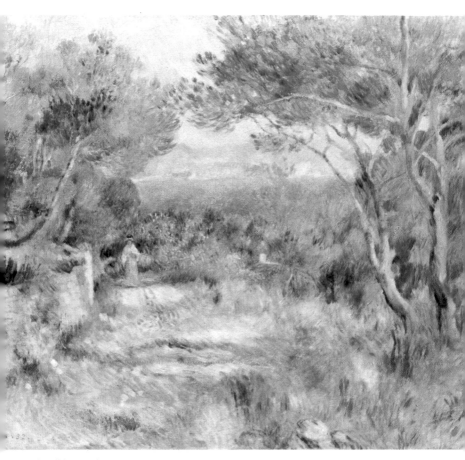

40 *Pierre-Auguste Renoir (1841–1919) : L'Estaque. 1882. Museum of Fine
Arts, Boston, Mass.*

rich in matter as well as bright colours and a general luminosity. When in 1885 he met Seurat and Signac, Pissarro was attracted by the new Pointillist technique and adopted it in some of his paintings. However, the intellectual and systematized character of this way of seeing things was alien to his more spontaneous inclination. Shortly afterwards he returned with renewed confidence to his typically Impressionist idiom and developed and deepened his powers of expression, producing results that are among the best of the whole School. The generous Bazille, always ready to share with his friends the trifling financial aid contributed by his family, the calm Caillebotte, Piette and Guillaumin and the Italian Zandomeneghi were among others of the Impressionist movement. In addition three women made important contributions – the American Mary Cassatt, a pupil of Degas; the Frenchwoman Eva Gonzales, who reflects, though in a minor way, the progressive stages of her master, Manet, and Bertha Morisot, who was married to a brother of Manet. This exquisite artist brought her whole feminine sensibility to the recording on her canvases of fleeting moments in her daily life, enveloping them in an intimacy not unlike that inspired by the pages of a diary. A beloved, familiar face, some flowers in a vase, a still life on a table, such are her favourite themes, and her works are among the most clear and uncomplicated in the Impressionist idiom.

One of the great merits of Pissarro, who was a trusted and generous friend to all those younger artists who painted with and around him, is that he encouraged Cézanne in the difficult years of his early painting.

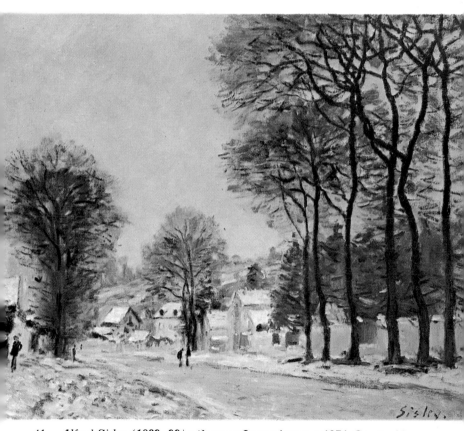

41 *Alfred Sisley (1839–99) : Snow at Louveciennes. c 1874. Courtauld Institute Galleries, London.*

41 Alfred Sisley (1839–99): *Snow at Louveciennes. c*
1874. Courtauld Institute Galleries, London.
Louve-ciennes was one of Sisley's special villages, which
he painted many times with a quiet simplicity and a special
concern for the changing moods of the seasons.

42 Alfred Sisley (1839–99): *Flood at Port-Marly*. 1876.
Musée du Louvre, Paris.
Sisley painted three fine versions of this scene, working
from different angles to the building; in this work there is a
chill atmosphere of melancholy represented in the blank
stretch of water and the cold colours everywhere apparent.

43 Alfred Sisley (1839–99): *The path to the old ferry*.
c 1880. Tate Gallery, London.
This painting is characterized by the subtle play of greens
in the foreground grass and trees and on the woody slopes
across the water.

44 Camille Pissarro (1830–1903): *Garden and orchard in
blossom: spring at Pontoise*. 1877. Musée du Louvre, Paris.
This is one of Pissarro's many views of Pontoise, a subject
Cézanne took up in the same period, and depicts the path
to the ravine seen from the Hermitage.

45 Camille Pissarro (1830–1903): *Mist effects: Ile
Lacroix, Rouen*. 1888. Museum of Art, Philadelphia;
John G. Johnson Collection.
Pissarro's concentration on effects of light, bringing out
contrasts between light and shadow, turned him in due
course to experiment with Divisionism.

46 Camille Pissarro (1830–1903): *Peasant girl having
breakfast*. 1881. The Art Institute, Chicago.
Pissarro was a more versatile artist than for example
Sisley. These three examples demonstrate his adaptability
in terms of style and subject matter.

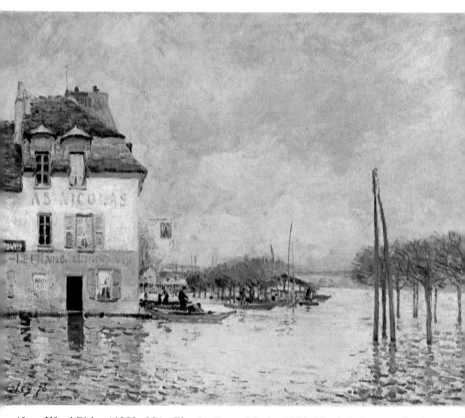

42 *Alfred Sisley (1839–99) : Flood at Pont-Marly. 1876. Musée du Louvre, Paris.*

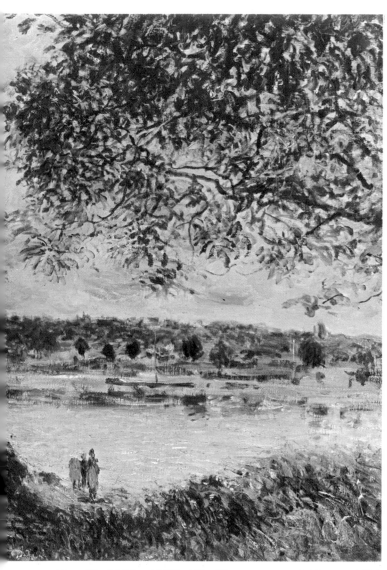

43 *Alfred Sisley (1839−99) : The path to the old ferry. c 1880.*
Tate Gallery, London.

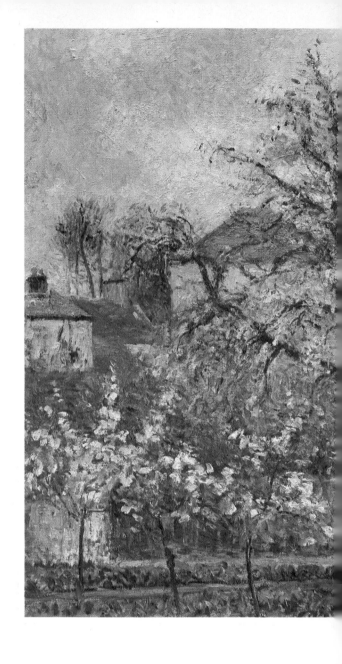

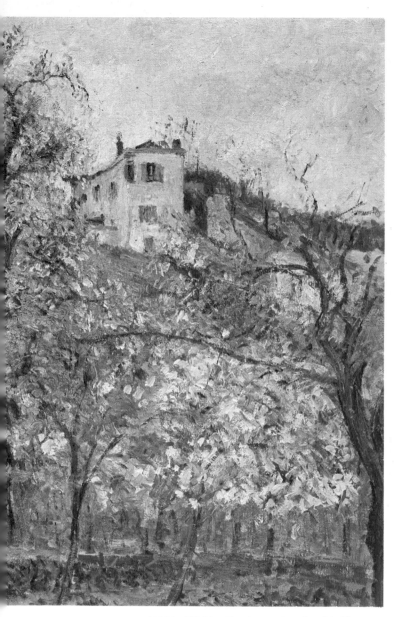

44 Camille Pissarro *(1830–1903)* : *Garden and orchard in blossom :
spring at Pontoise. 1877. Musée du Louvre, Paris.*

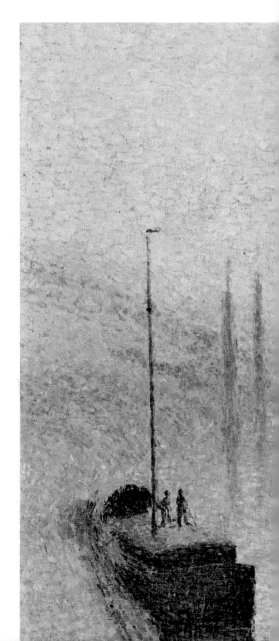

45 *Camille Pissarro
(1830–1903) : Mist
effects : Ile Lacroix,
Rouen. 1888. Museum
of Art, Philadelphia.*

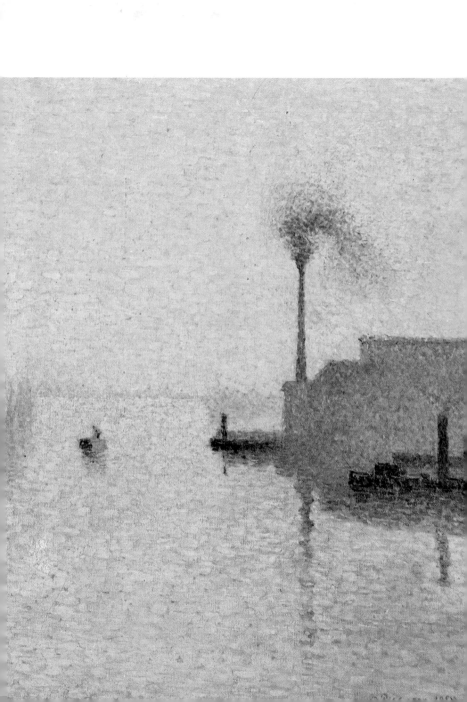

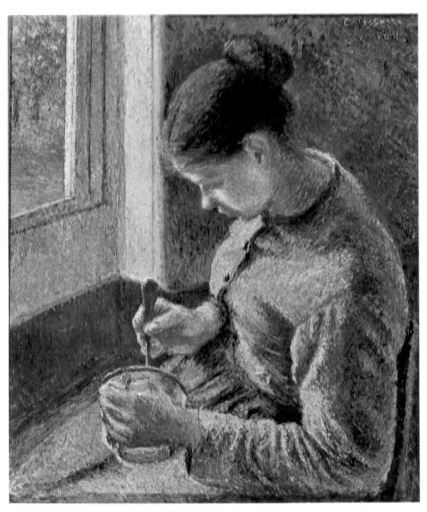

46 *Camille Pissarro (1830–1903) : Peasant girl having breakfast. 1881.*
The Art Institute, Chicago.

The story of Cézanne's artistic vocation is in fact among the most troubled, the most hedged-in with problems that we know. For a whole decade, 1860–70, with desperate obstinacy, the young artist from Aix explored every road in his search for a language capable of expressing what he vaguely felt his message to be. His painting in those years was harsh and dense, full of symbolic and literary allusion; but, from the start of his relations with Pissarro in 1872 when he discovered the language of the Impressionists, Cézanne learned to look at the world directly, to recognize a new source of inspiration in the forms and colours of nature. To this extent Cézanne was involved in Impressionism, even though it was only really a first encounter with nature. In time his intentions and the results he obtained with them took a wholly different direction.

The aim of the Impressionists was to portray the fleeting truths about life that run through nature, the momentary shudder; whereas what Cézanne wanted was to represent the eternal and indestructible values of nature. If the Impressionists fragmented their forms, imbuing them with light, Cézanne pieced them together, plastically, in orderly structure. He saw people, landscapes and still lifes in terms of harmony and consistency, which he could only successfully render by a careful and sober technique. In practice he built up his pictures in various series of planes, using colour to suggest relationships and to delimit the various areas of the canvas. In Cézanne's painting decoration does not exist. If, to start with, he used well-marked contours to define the forms, he discovered subsequently that he could construct them

with colour alone: *'Quand la couleur a sa richesse, la forme a sa plentitude,'* he asserted. There followed a number of major works characterized by a broad structural pattern – the exaltation of pure uncluttered volumes crystallised in the light. The harmony of Cézanne's pictures, the meeting-point of mind and feeling, intuitive observation combined with truth and intellectual activity – these qualities were achieved through direct contact with nature, wresting from it the eternal laws of equilibrium by which it is governed. Such harmony is beyond time; in Cézanne a fixed point was established in the history of art, on which all eyes were turned, finding in it a lasting inspiration. Gradually, towards the close of the century, after years of misunderstanding and neglect, Cézanne's fame was affirmed and consolidated, and all the artists of the new generation recognized him as the great master. Gauguin was enthusiastic about Cézanne's use of broad areas of colour even if he himself was to adopt and distort them for his own decorative and symbolic purposes. Nor were Cézanne's rigorous structures, with their extraordinary power of synthesis and reduction to geometrical essence, unconnected with the birth of Cubism, as defined by Braque and Picasso. Cézanne's lesson is therefore part and parcel of the new art of the twentieth century.

Around 1884, the Impressionist group began to break up while the individual artists, once the enthusiasm for the collective adventure had evaporated, followed their own courses. In the meantime the artistic life of Paris had been renewed, Monet and Renoir had ceased to be a novelty, and there were attempts to

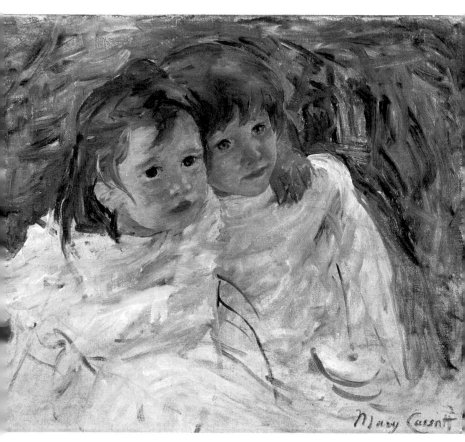

47 *Mary Cassatt (1844–1926) : The sisters. c 1885. Art Gallery, Glasgow.*

48 *Berthe Morisot
(1841–95) : Catching
butterflies. 1873.
Musée du Louvre,
Paris.*

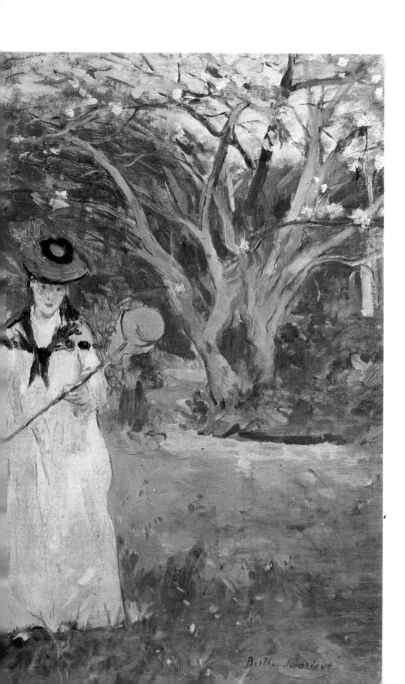

Berthe Morisot

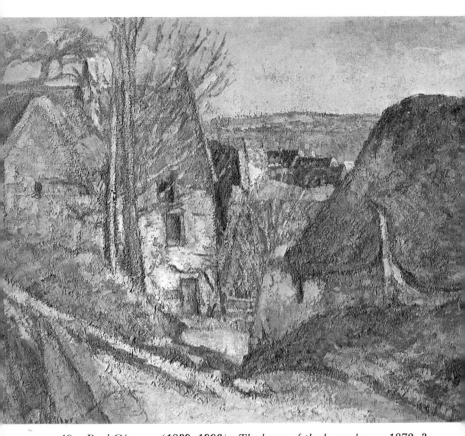

49 *Paul Cézanne (1839–1906) : The house of the hanged man. 1872–3.*
Musée du Louvre, Paris.

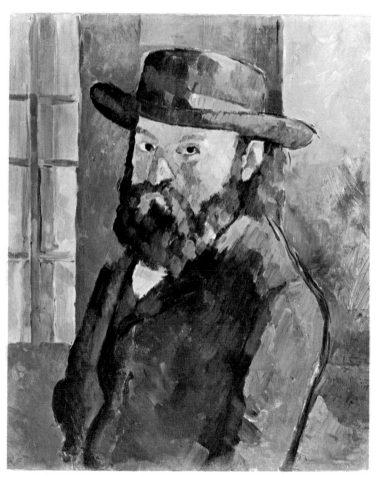

50 *Paul Cézanne (**1839–1906**) : Self-portrait in a black hat.*
1879–82. Kunstmuseum, Bern.

47 Mary Cassatt (1844–1926): *The sisters. c* 1885. Art Gallery, Glasgow.
The slightness of the subject is redeemed by the candour and the incisiveness of the execution.

48 Berthe Morisot (1841–95): *Catching Butterflies.* 1873. Musée du Louvre, Paris.
Berthe Morisot's artful composition, in which the catcher is shown advancing almost to the edge of the canvas, combines a gentle lyricism and a feeling for nature.

49 Paul Cézanne (1839–1906): *The house of the hanged man.* 1872–3. Musée du Louvre, Paris.
Cézanne compositions are tightly organized within their own rigorous frameworks: nature is taken apart, unnecessary or merely ornamental components removed and a new scene of greater aesthetic potency is assembled.

50 Paul Cézanne (1839–1906): *Self-portrait in a black hat.* 1879–82. Kunstmuseum, Bern.
This self-portrait is based on a play of angles and parallel lines typical of Cézanne's method of geometrical analysis; in many areas of the painting colour alone is used to delineate the various forms.

51 Paul Cézanne (1839–1906): *The card-players.* 1890. Musée du Louvre, Paris.
Cézanne turned in time from examinations based on lighting and the fleeting appearance of things to a more cautious study of the essential nature of objects.

52 Paul Cézanne (1839–1906): *Jourdan's cottage.* 1906. R. Jucker Collection, Milan.
In this brilliantly rendered scene, at once scraped bare of inessentials and yet flooded with patches of evocative and seductive colour, Cézanne has reached almost the antithesis of the 'impression'.

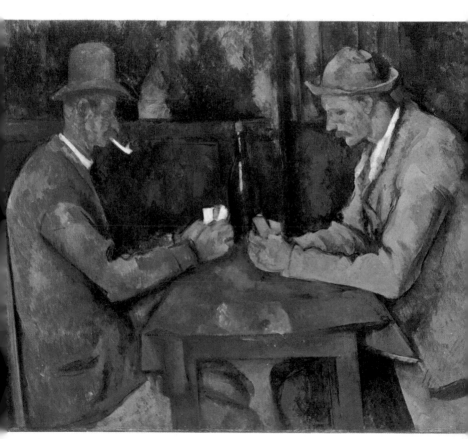

51 *Paul Cézanne (**1839–1906**) : The card-players.* **1890**. *Musée du Louvre,*
Paris.

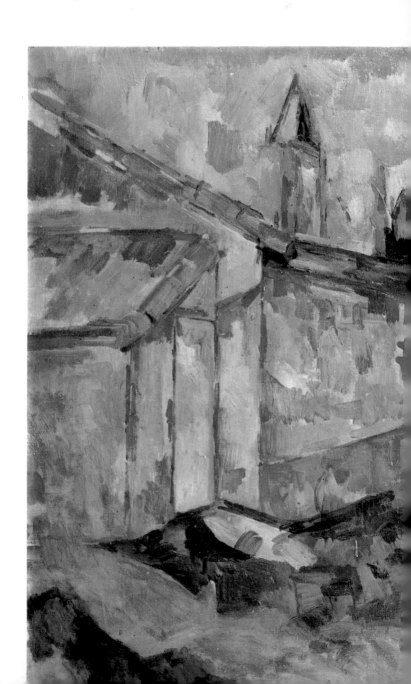

52　*Paul Cézanne (1839–1906) : The Jourdan cottage. 1906. R. Jucker Collection, Milan.*

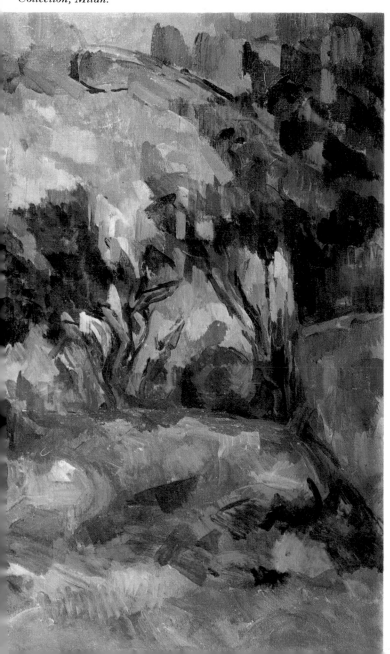

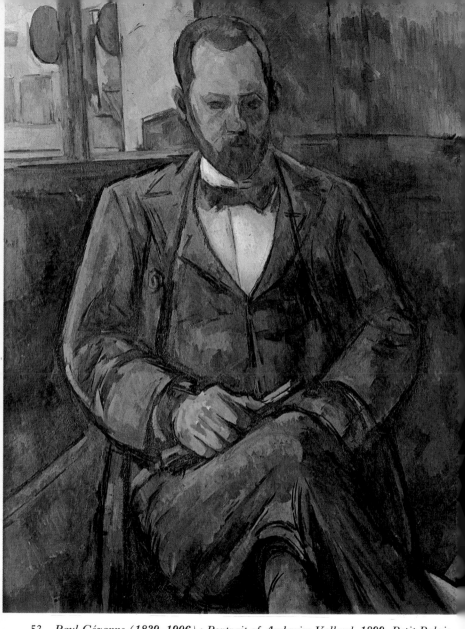

53 *Paul Cézanne (1839–1906) : Portrait of Ambroise Vollard. 1899. Petit Palais, Paris.*

supersede them with new formulas and new visions. It was in this artistic climate that Georges Seurat, a very gifted painter, destined to die at the early age of thirty-two, came to maturity. Taking Impressionism as his starting-point he accepted and then extended Monet's optical analysis of reality to its logical extreme. Patiently he studied the breaking-up of light on objects into innumerable blobs of colour. He applied the results of scientific studies of optical vision to his own discoveries and from them deduced a precise and systematic formula for reproducing the blobs in painting, which became known as Pointillism or Divisionism. What he proposed was to recreate the forms of reality by applying the processes of the human eye to painting, namely the dispersal of the object into separate dots of light, which the viewer's retina then reconstituted into a solid unity. The new technical discipline that exploited the breaking-up of tones in their composed original elements and then distributed them in separate points of colour pre-supposed the experiments of Impressionism but it turned them in a totally different direction: the lyrical abandonment to the aspects of nature became, first with Seurat then with Signac and other adherents of the Pointillist group a rational desire to submit nature to a preconceived plan of composition. As in Cézanne, if from a completely different angle, inner emotion and the impression of the eye were submitted to strict intellectual analysis.

Une Baignade, Asnières, the first picture by Seurat that testifies to his new vision, impresses by its premeditated structure, organized on a system of

rigorous perspective, and by the sober solidity of the forms and the intellectual severity with which the whole thing is planned. The technique employed in no way hindered Seurat from expressing himself freely; rather it served him as an instrument for setting down how he saw the world. The process resulted in a masterpiece – the painting *Sunday afternoon at La Grande-Jatte*. Here every element takes its place in a scheme of perfect and coherent unity, from the balanced distribution of the figures that people the river bank to the clear articulation of light and shadow. Later, as Seurat became increasingly interested in the technical and intellectual aspects of his language, and involved in theoretical demonstrations of his system of painting, he forfeited some of his spontaneity. However, his teaching won wide acceptance and as well as the faithful Signac, the best and liveliest of Seurat's disciples, and Pissarro, who enjoyed a Divisionist phase, there were men in France such as Dubois-Pillet and Maximilien Luce and in other European countries painters like Edmond Cross and Van Rysselberghe. With the exception of Signac the results they achieved are on the whole fairly modest. If the discoveries of the Impressionists had attracted and united for some years the best talents in French painting, the period immediately following the main wave of Impressionism produced a new situation in which the artists found themselves more alone and isolated than ever in their quest for new ways of experimenting. Their faithful adherence to the world of appearances, their untroubled delight in the contemplation of nature must now be left behind.

Artists saw the need to return to their inner investigations, somehow to involve nature with their anxieties and aspirations and to pass beyond the impression of something visible and external to express the complex world of the invisible, the world of the spirit. It was no longer a matter of suggesting an objective world but of objectivizing as far as possible a subjective one. It was on this ground that the fruitful adventure of *fin-de-siècle* Symbolism germinated and sprang into being, and also here that the tragic and violent personailty of Vincent van Gogh unfolded.

Dutch by birth, van Gogh came to painting after working in the Goupil Gallery – formerly owned by an uncle – and then, after leaving the art business, as a lay preacher among the miners of Borinage in Belgium. He suffered greatly for his beliefs, taking his ascetism to extreme limits, and was replaced in the job. He returned to Holland and began to paint, at first producing ponderous works lacking in imagination and laborious in execution. The subjects – peasants and labourers, interiors of hovels – revealed his humanitarian outlook, his sensitivity to the problems and feelings of the poor. Indeed, from his difficult start to the end, his paintings continue to be a faithful mirror of his inner torments. Van Gogh loved the world of men and nature passionately and unreservedly; but with no less emotion he realized the impossibility of manifesting this love, of communicating with his fellow men, establishing a relation with exterior reality. Hence his anguish, his violent and desperate longings, his incurable fever that led to madness and suicide. Reaching Paris in 1886, he

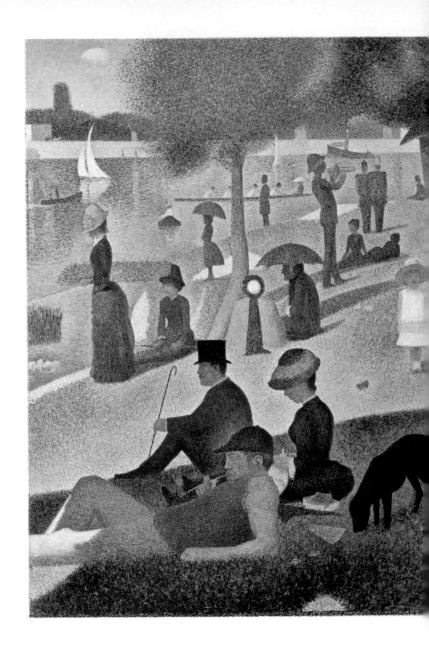

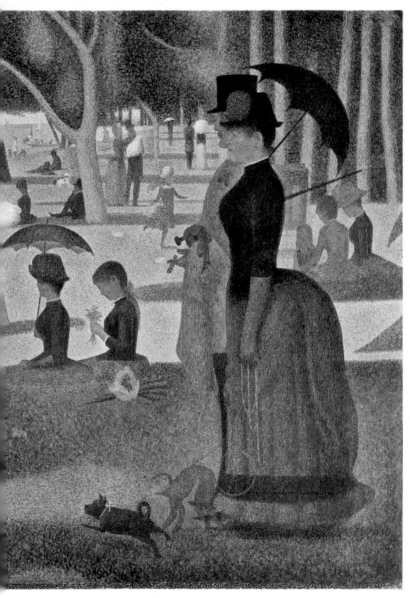

54 *Georges Seurat (1859–91) : Sunday afternoon on the Ile de la Grande-Jatte. 1884–86. The Art Institute, Chicago.*

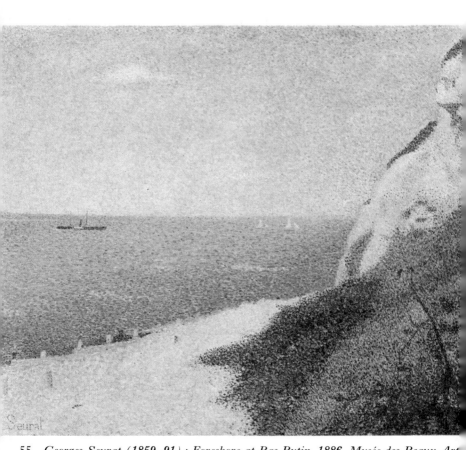

55 *Georges Seurat (1859–91) : Foreshore at Bas Butin. 1886. Musée des Beaux-Art Tournai.*

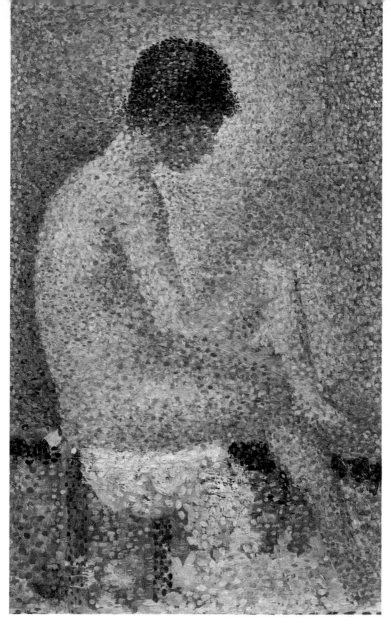

56 *Georges Seurat (1859–91) : Seated model in profile, a study for*
The Models. 1887. Musée du Louvre, Paris.

53 Paul Cézanne (1839–1906): *Portrait of Ambroise Vollard*. 1899. Petit Palais, Paris; Vollard Collection.
By the turn of the century Cézanne was far from the Impressionists' world: even the figure of this man has been carefully segmented and schematically rebuilt so that parts of his head seem interchangeable with parts of the background.

54 Georges Seurat (1859–91): *Sunday afternoon on the Ile de la Grande-Jatte*. 1884–6. The Art Institute, Chicago.
This is Seurat's masterpiece. In it he has taken a favourite Impressionist scene, a moment of free, uninhibited life and reorganized it intellectually; the palette is refined and follows a strict system, the figures are flattened and more monumental.

55 Georges Seurat (1859–91): *Foreshore at Bas Butin*. 1886. Musée des Beaux-Arts, Tounai.
Seurat's experiments were directed towards representing form geometrically and producing luminous effects through breaking down the natural light into its constituent elements.

56 Georges Seurat (1859–91): *Seated model in profile,* a study for *The Models*. 1887. Musée du Louvre, Paris.
This detail underwent a major modification in the final version. Line here is functioning less and less as contour and more (see for example the line of the model's back) as a focus of luminous vibrations.

57 Georges Seurat (1859–91): *The Circus*. 1890–1. Musée du Louvre, Paris.
A return to the artificial world of entertainment, which, lovingly investigated by Degas and studied by Toulouse-Lautrec in a more satiric vein, is here rendered in stylized fashion as Seurat sought to give visible shape to emotional feeling.

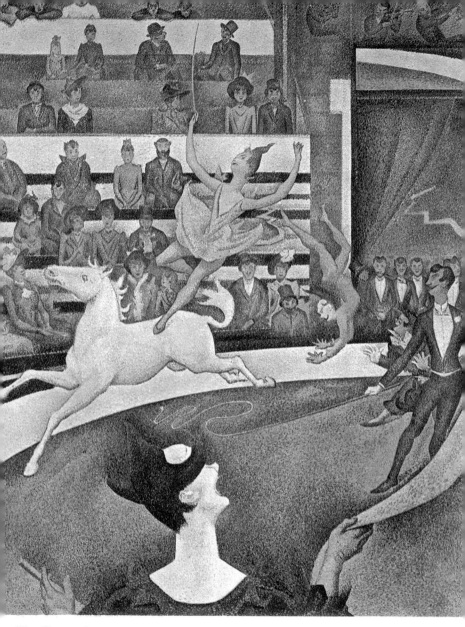

57 *Georges Seurat (1859–91) : The Circus. 1890–1. Musée du Louvre, Paris.*

moved in the most distinguished artistic circles, and there discovered the fascination of bright, luminous colour and admired the bold synthesism of Japanese prints recently imported into Europe. His painting underwent a transformation, became animated with a new vitality, articulated in free, uninhibited compositions in which the colour exploded in all its rich exuberance. And so began his brief and intense period with a rapid succession of works which accompanied his removals from Paris to Arles, from the Hospital of Saint-Rémy to Auvers-sur-Oise. He was an innovator, the master of a new idiom that exalted colour, creating drama in the feverish patterns of his brush-strokes. Van Gogh bequeathed a spiritual legacy in each of his paintings. There is no peace in the world, as there is no peace in his diseased spirit. His trees and flowers, men and cornfields suffer as he does, writhe and are consumed in the same distress. Yellow, Van Gogh's favourite colour, is no longer the warm colour of the sun; it has become an obsessional term in a private language of frenzy. Such an all-consuming flame could not burn long, and in the summer of 1890 van Gogh concluded his days tragically with a revolver bullet.

Symbolism, whereby the objective representation of reality is replaced by a vision that charges reality itself with spiritual significance and corresponds to the artist's innermost needs, became one of the dominant threads in the complex panorama of Post-Impressionism. Literature too, especially poetry, was directed to similar ends and offered new themes for pictorial treatment. Manifestos appeared – that of Moréas in

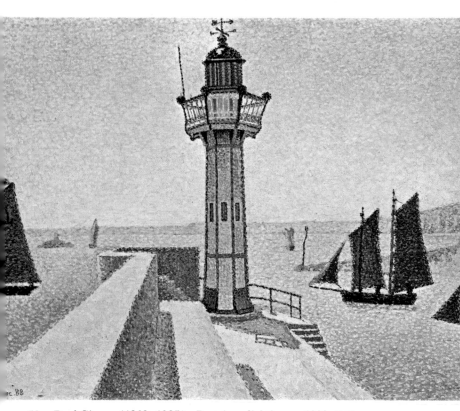

58 *Paul Signac (1863–1935) : Portrieux lighthouse. 1888. Rijksmuseum Kröller-Müller, Otterlo.*

58 Paul Signac (1863–1935): *Portrieux lighthouse*. 1888.
Rijkmuseum Kröller-Müller, Otterlo.
In this picture the strong linear elements of the light-house, masts and harbour wall seem to compete rather unhappily with the pale, watery zones of sea and sky.

59 Paul Signac (1863–1935): *Woman doing her hair.*
1892. Madame Ginette Cachin-Signac Collection, Paris.
After the death of Seurat in 1891 Signac became the leader of the Divisionist School, though by then his paintings were veering away from the scientific principles of colour towards a more abstract handling of his composi-tions.

60 Theo Yan Rysselberghe (1862–1926): *Perkiredec Point*. 1889. Rijkmuseum Kröller-Müller, Otterlo.
Van Rysselberghe came to Pointillism after seeing Seurat's *La Grande-Jatte ;* from then on, abandoning the naturalistic idiom that had characterized his earlier and less important paintings, he became an ardent Seurat disciple.

61 Maximilien Luce (1858–1941): *View of Montmarte*, 1887. Rijkmuseum Kröller-Müller, Otterlo.
The Divisionists or Neo-Impressionists, though they systematically broke up colour into its constituent elements in accordance with scientific principles, varied considerably in the quality of their work. In this example, the Divisionist 'mosaic' seems merely to overlay a con-ventional piece of realistic observation.

62 Henri-Edmond Cross (1856–1910): *Portrait of Madame Cross*. 1891. Musée National d'Art Moderne, Paris.
Henri-Edmond Cross was one of the founders of the Society of Independent Artists in 1884, and his feeling for colour puts him among the precursors of Fauvism.

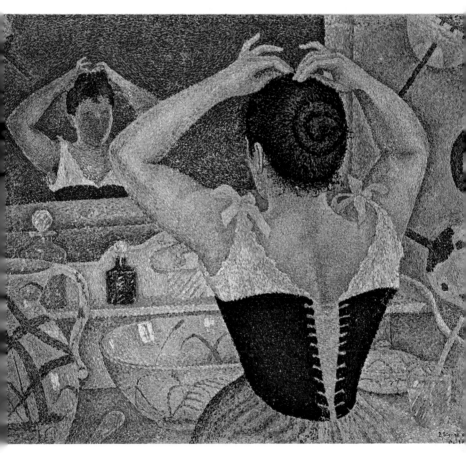

59 *Paul Signac (1863–1935) : Woman doing her Hair. 1892. Mme Ginette Cachin-Signac Collection, Paris.*

60 *Theo van Rysselberghe (1862–1926) : Perkiredec Point. 1889. Rijksmuseum Kröller-Müller, Otterlo.*

61 *Maximilien Luce (1858–1941) · View of Montmartre. 1887. Rijksmuseum Kröller-Müller, Otterlo.*

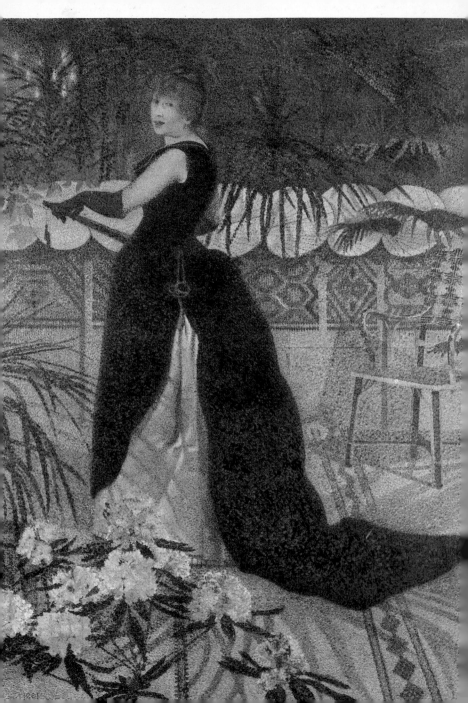

1886, that of Morice in 1889 – defining the aims and characteristics of Symbolism in more precise terms. Moréas declared that 'the essential character of symbolic art consists in avoiding the expression of the pure idea', and Morice pointed to 'synthesis' as the most typical feature of Symbolism. This synthesis was 'a fruitful pact between natural science and metaphysics', that is, between realism and dream, and 'conveys the spirit back to its true country'.

The two most important protagonists of Symbolism in art were Gaugin and Odilon Redon. Paul Gauguin began as a collector of Impressionist works, he was a friend of Pissarro with a dilettante's interest in the new painting; after some initial success with his own spare-time works he began in the early 1880s to paint seriously and from that moment his life was transformed. He abandoned his wife, children and a safe job (he was a stockbroker) to embark on a course fraught with insecurity. He worked with Pissarro and Cézanne at Pontoise, and exhibited with the Impressionists, but soon his work revealed a new language. It simplified the analytical vision of Impressionsim and replaced the little touches of colour by broad flat areas that have a simultaneously decorative and evocative value. The solid structure of the compositions and the rich quality of the paint are a clear indication of the dominant influences of Pissarro and Cézanne, but the works he brought back from his voyage to Martinique and the Antilles in 1887 already show an original note which was to be strengthened following his meeting with Emile Bernard, a young painter from the *atelier* Gormon. Bernard was an

Henri-Edmond Cross (1856–1910) : Portrait of Madame Cross. 1891. Musée National d'Art Moderne, Paris.

intelligent and ingenious experimenter from whom Gauguin learned to enclose his forms between strong black outlines, using a technique akin to the enameller's *cloisonnés*. At Pont Aven in Brittany came the birth of the first works in Gauguin's mature idiom: canvases in which the third dimension is deliberately abolished, and compositions are articulated in accordance with marvellous harmonies of form and colour, boldly stylized, voluptuously decorative but rich in symbolic, even mystical significance; examples include the *Yellow Christ* and *Vision after the Sermon*. Following a brief period at Arles with van Gogh, Gauguin went to Paris where his fame was continually increasing, fed by his persuasive talk and continuous reference to the 'primitive' world, the only world that could genuinely inspire an artist. Obsessed with this idea, he sailed for Tahiti in 1891 to put it into practice. There he discovered the magic of a nature abundantly rich and uncorrupted, a simple and miraculously unspoiled life. All the colours, scents, mysteries, the excitement of the exotic entered his painting; he exalted mysticism and sensuality, the simplicity and obscure instincts of primitive peoples. He went back to Paris but only for two years. In 1895 he returned to Tahiti and subsequently moved on to the Marquesas Islands where he was to remain, still painting, up to his death. Occasionally philosophical and literary preoccupations seem to restrain his freedom of expression; more often, however, truth and fantasy, symbolism and reality achieved a balance in his work.

More subtly intellectual and precious, Odilon Redon

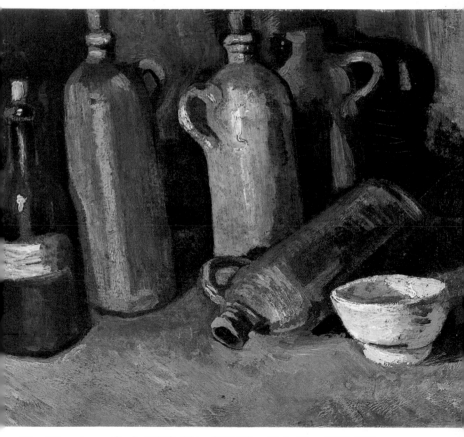

63 *Vincent van Gogh (1853–90) : Still life with bottles. 1884. Rijksmuseum
Kröller-Müller, Otterlo.*

63 Vincent van Gogh (1853–90): *Still Life with bottles*.
1884. Rijkmuseum Kröller-Müller, Otterlo.
The dense colour, applied in thick brush-strokes, suits
the static, weighty character of the subject; a fairly early
work, it was painted at Nuenen, Holland, in 1884.

64 Vincent van Gogh (1853–90): *Night café*. 1888.
Stephen C. Clark Collection, New York.
Van Gogh used scenes from the life around him to convey
powerful inner convictions: of this bleak painting he wrote,
'I have tried to express through the reds and greens the
awful passions of human nature.'

65 Vincent van Gogh (1853–90): *Summer evening near
Arles*. 1888. Kunstmuseum, Winterthur.
Van Gogh wrote: 'Here is another landscape: sun setting,
sun rising? Summer sun at all events. The city is violet,
the star yellow, the sky blue-green.'

66 Vincent van Gogh (1853–90): *Crows flying over a
cornfield*. 1890. Vincent van Gogh Foundation Collection,
Amsterdam.
Painted at Auvers, shortly before his death, this is one of
van Gogh's last paintings: it is a work of utterly uninhibited
dramatic intensity, a cry of distress at the impossibility of
his situation.

67 Vincent van Gogh (1853–90): *The geisha*. 1888.
Chester Dale Collection, National Gallery of Art,
Washington, DC.
The title of this canvas was inspired by the famous
novel, Madame Chrysantheme, by Pierre Loti. It
belongs to van Gough's period in Arles, where he was
still much taken by *japonisme* and the idea of combining
qualities of Japanese prints with the brilliant light of the
Midi.

64 *Vincent van Gogh (1853–90) : Night café. 1888. Stephen C. Clark Collection, New York.*

65 *Vincent van Gogh (1853–90) : Summer evening near Arles.
1888. Kunstmuseum, Winterthur.*

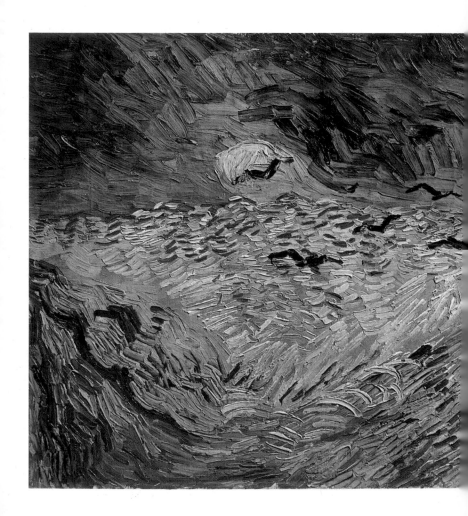

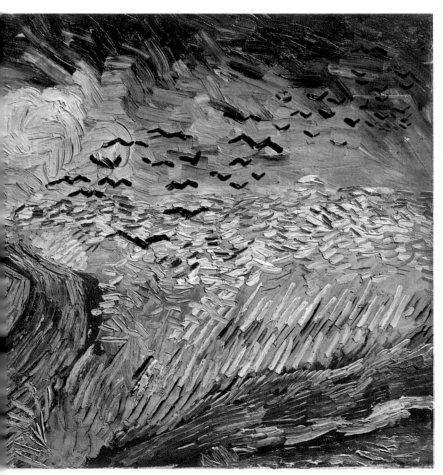

66 *Vincent van Gogh (1853–90) : Crows flying over a cornfield 1890.
Vincent van Gogh Foundation Collection, Amsterdam.*

is the other great exponent of French Symbolism in the *fin-de-siécle* period. At Bordeaux where he was born, Redon underwent the influence of Rudolph Bresden, also a painter of skill, who taught him to recognize sources of inspiration for art in the fantastic, in myths, and in the spiritual reality of the artist's private world. And Redon, by temperament a visionary and a dreamer, could have asked for nothing better than to be set down on that road. In Paris he became enthusiastic for brilliant colour and Delacroix's Romantic excitement; he also studied Corot with respect and understanding. Yet, at heart, he stayed true to Bresden, to whom he owed, among other things, his preference for black and white. Embracing these violently contrasting influences, Redon proceeded to make charcoal sketches of the anguished images that populated his Paris nights: his dreams, as though controlled by a lucid conscious mind, acquired the consistency and immediacy of reality. The fertility of his imagination found its equivalent in his pictorial genius, and an amazingly rich, nimble and evocative language gave shape to complex and shadowy notions in which the human element was continually involved with fantastic motifs, creations taken from organic and inorganic life. The faces that unexpectedly materialize between the coils of a snake and the petals of a flower, eyes that peer out of dark shadows, speak to us unequivocally of a mysterious, spiritual life, omnipresent and intuitively recorded by the artist's sensibility. These characteristics, particularly typical of the sketches and black and white drawings, are also in evidence in Redon's paintings, in which the

element of exterior reality is continually transcended in the artist's search for a more intimate and hidden reality. The latter is revealed by allusion in the magic and rarefied atmospheres he creates. The literature of his time, from Baudelairs to Huysmans, has a particular place in Redon's art – but this does not make him a 'literary' painter; his rich imagination and innate genius as a painter predominate over theoretical considerations.

Because of the courage with which he faced away from the triumphant path of Naturalism in the years 1870–80 and the important role he came to occupy in the vanguard of Post-Impressionism, Redon was later considered to be a leader of the new painting at the end of the century and traces of his influence recur in many different parts of Europe.

Among the personalities who enriched the Paris scene in the years immediately following Impressionism was Henri de Toulouse-Lautrec, one of the most lively, independent and rebellious talents to be found in the painting of this period. The heir of a noble family of ancient lineage, Lautrec turned to painting as though to defy a cruel fate that, following two accidents, had made him a ridiculous dwarf, hardly capable of walking without the aid of a stick. Fortunately he was endowed with an exceptional intelligence and an instinctive flair for capturing exterior reality, a quality already observable in his childhood sketches. He submitted to a long and strict apprenticeship in the Paris *ateliers* of Bonnat and Cormon, resolved to master all the secrets of pictorial technique. However, his career had little to do with official,

68 Emile Bernard (1868–1941) : Portrait of a Grandmother. 1888.
Stedelijk Museum, Amsterdam.

69 *Paul Gauguin (1848–1903) : La belle Angèle. 1889. Musée du Louvre, Paris.*

68 Emile Bernard (1868–1941): *Portrait of a grand-mother*. 1888. Stedelijk Museum, Amsterdam.
Emile Bernard, together with Paul Gauguin and others, elaborated the fundamental principles of symbolic art, steering it towards a simpler, more harmonious kind of painting, dividing their subjects into zones of line and colour.

69 Paul Gauguin (1848–1903): *La belle Angele*. 1889. Musée du Louvre, Paris.
Gauguin used broad, rhythmically applied brush-strokes and emphatic colours to convey a subjective world; his ideas were at this time firmly on the side of the Symbolists, who sought to produce work that was both spiritual and decorative.

71

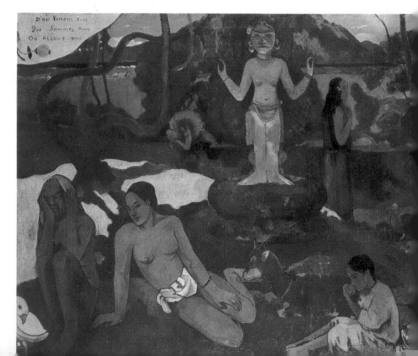

70 Paul Gauguin (1848–1903): *The calvary*. 1889.
Musées Royaux des Beaux-Arts, Brussels.
At Pont-Aven Gauguin had experimented with religious
imagery: here he constructs an expressive picture of
primitive devoutness using distortion and a bold rhythmic
plan.

71 Paul Gauguin (1848–1903): *D'où venons-nous? Que
sommes-nous? Ou allons-nous?* 1897. Museum of Fine Arts,
Boston, Mass; Arthur Tompkins Fund.
Gauguin wrote of this masterly evocation of the primitive
spirit: 'I put my whole vital strength into it . . . and such
clarity of vision, without second thought, that the rapidity
of the execution disappears and gives way to life itself.'

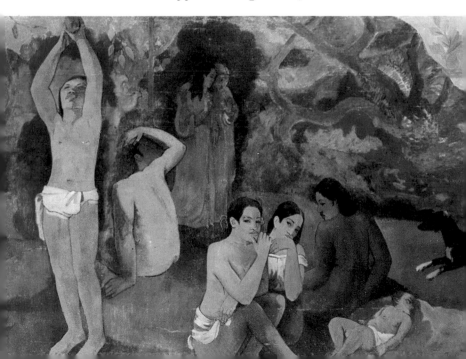

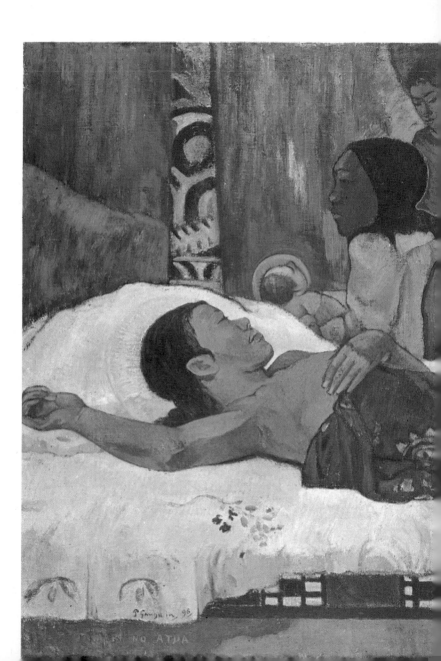

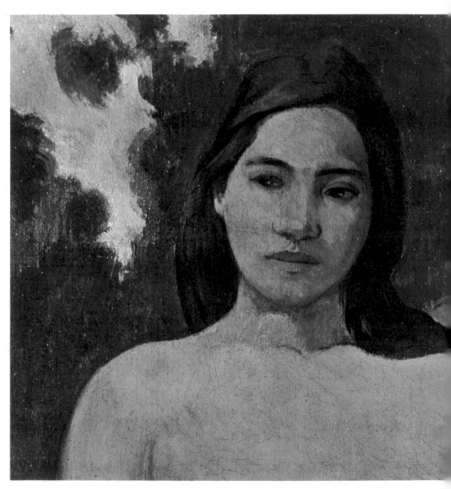

73 *Paul Gauguin (1848–1903) : Tahitian girls with mango flowers (detail). 1899.*
Metropolitan Museum of Art, New York.

136

academic painting; he reserved his greatest admiration for the Impressionists – Degas in particular. His language gradually matured as he became familiar with the new and revolutionary experiments afoot in the capital. The objectivity with which Degas confronted and investigated the seedy areas of suburban Paris life and the brilliant world of the theatre, the fidelity and incisiveness of his touch, profoundly impressed Toulouse-Lautrec. He found in these qualities the basic equipment that was to serve his ambition: the portrayal of humanity in its most authentic and unconventional aspects. Having rented a studio in Montmartre, Lautrec proceeded to steep himself in the smoky and feverish atmosphere of night clubs and brothels, going to revues and plays, forming relationships with actors and actresses, visiting circuses. He searched everywhere in his quest after the genuine aspects of human personality, catching it in the frenzy of the dance, the spontaneous gesture made in the intimacy of an alcove, the magic revelation of a stage-scene. Posters, drawings, lithographs, paintings filled his short, intense life. He left an inimitable mark with his aggressive compositions, violent – but never cruel in their exposure of vice and weakness, revealing the intimate physical and spiritual characteristics of men and women scrutinized and stripped to the very fibres of their being. The portrait Lautrec has left us of his period is one of the most perceptive, fascinating and telling that any artist has ever painted.

In his exceptional skill at creating atmosphere Lautrec recalls another artist, Jean-Louis Forain. Beginning

74　*Odilon Redon (1840–1916) : Portrait of Mademoiselle Violette Heymann. Museum of Art, Cleveland, Ohio.*

72 Paul Gauguin (1848–1903): *Nativity*. 1896. Bayerische Staatsgemäldesammlungen, Munich.
Some details of this bold and spacious work, such as the mother's hands or the baby's head, express a tenderness that Gauguin often preferred to conceal.

73 Paul Gauguin (1848–1903): *Tahitian girls with mango flowers* (detail). 1889. Metropolitan Museum of Art, New York; gift of William Church Osborn, 1949.
Gauguin portrays his Eve in bright colours and with a simplicity that goes beyond theoretical formulas; in Tahiti Gauguin sought to embody in his own work the primitive art that 'derives from the spirit and makes use of nature'.

74 Odilon Redon (1840–1916): *Portrait of Mademoiselle Violette Heymann*. Museum of Art, Cleveland, Ohio.
Alongside the attractive image of the languid, pensive sitter floats a dream-world peopled by shapes that her face had evoked temporarily in the artist's mind.

75 Odilon Redon (1840–1916): *Armour. c* 1891. Metropolitan Museum of Art, New York.
'My art goes to the limits of chiaroscuro,' wrote Redon, whose prolific output of bizarre charcoal sketches had amazed and delighted the followers of Decadent art.

76 Odilon Redon (1840–1916): *Night* (detail). 1910–11. The Abbey Library, Fontfroide.
Redon tries to give substance to abstract entities and vague states of mind on canvases in which the basic ingredient is not colour but the evocative power and disposition of shapes drawn from nature, human life and the artist's own spirit world and the relationships and attitudes they strike *vis-à-vis* one another.

75 *Odilon Redon (1840–1916) : Armour. c 1891. Metropolitar Museum of Art, New York.*

76 *Odilon Redon (1840–1916) : Night (detail). 1910–11. The Abbey Library,*
Fontfroide.

his commercial career as a caricaturist he was actively connected with various periodicals in Paris and contributed a large number of satirical drawings exposing corruption and injustice. During World War I he produced some cruel and bitter caricatures of the Germans. In the curving lines that enclose simplified, distorted human forms the memory of Daumier is perpetuated, while the broad, rapid brush-strokes recall the painting of Lautrec.

It is said of Toulouse-Lautrec that he was too independent ever to submit to formulas and progammes, that he ignored the theoretical arguments that preoccupied so many contemporary artists, from Seurat to Gauguin. Henri Rousseau could claim with still more justification to be independent, though in a different way. This modest Customs official without any instruction produced works of great originality and merit, thanks to his innate lyricism and sincerity of feeling. His paintings were first shown in 1886 at the *Salon des Indépendants*, but the public jeered and only a few appreciated the fascination of his unspoilt candour, the childlike and exquisitely poetic vision in which the simplest natural phenomenen is seen as a miracle and ingenuously recorded. The faces of his friends, the events of everyday life, the landscape near his home, were his modest themes, and the affection with which he portrayed them is evidently so genuine and convincing that we cherish them today as delightful documents, unique in the history of art. When, later, Rousseau discovered and conquered the exotic world, the pictures he painted have the same disarming innocence of his previous work. The wild beasts

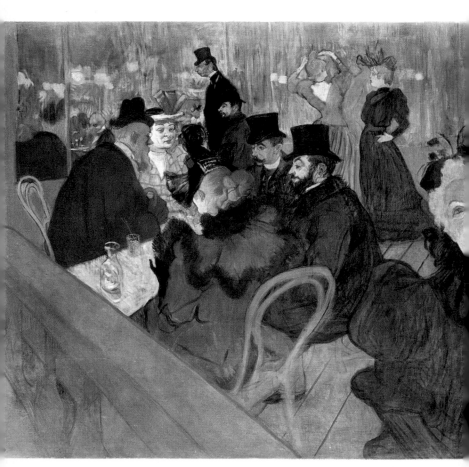

77 Henri de Toulouse-Lautrec (1864–1901) : At the Moulin Rouge. 1892.
The Art Institute, Chicago.

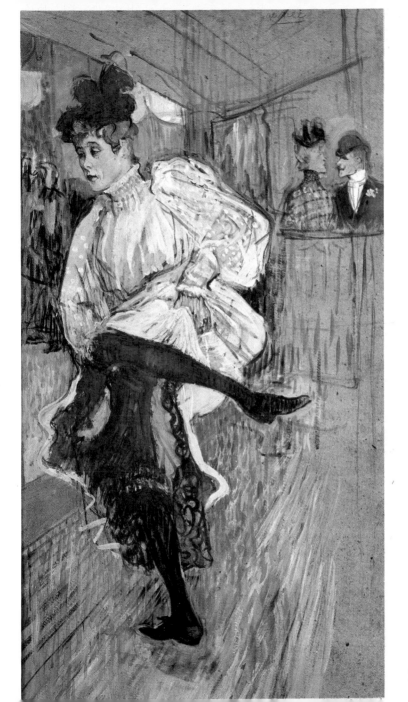

145

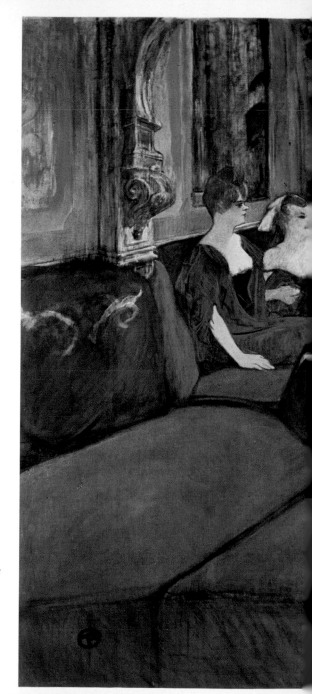

79 *Henri de*
Toulouse-Lautrec
(1864–1901) : In
the salon of rue des
Moulins. Musée
Toulouse-Lautrec,
Albi.

146

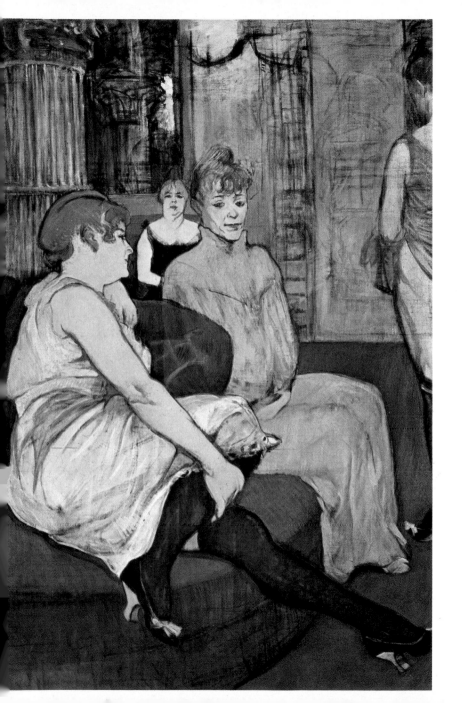

77 Henri de Toulouse-Lautrec (1864–1901): *At the Moulin Rouge*. 1892. The Art Institute, Chicago; Helen Brich Bartlett Collection.
Lautrec's regulars at the Moulin Rouge are picked out with complexions of every shade from white to luminous blue.

78 Henri de Toulouse-Lautrec (1864–1901): *Jane Avril dancing*. Musée du Louvre, Paris.
As the dance reaches its climax, Jane, a sad-faced, agile red head, twists her body nimbly under her flimsy dress.

79 Henri de Toulouse-Lautrec (1864–1901): *In the salon of rue des Moulins*. Musées Toulouse-Lautrec, Albi.
The unappealing women wait for commissions, their faces and bodies a few aggressive lines.

80 Henri de Toulouse-Lautrec (1864–1901): *Miss Mary Belfort*. 1895. Private Collection, Paris.
Several times Lautrec painted this Irish singer, she dolled herself up like a child, carried a black kitten in her arms and babbled infantile songs around the Paris cafés.

81 Henri Rousseau (1844–1910): *Self-portrait*. 1890. Narodno Gallery, Prague.
In the midst of an intense cultural ferment Rousseau, the Customs official, painted pictures of a most original kind but wished at heart to acquire an academic manner.

82 Henri Rousseau (1844–1910): *The anglers*. 1907–8.
In this extraordinarily bare painting three layers of river, land and sky stand in an almost vertical relationship.

83 Henri Rousseau (1844–1910): *War or the cavalcade of discord*. 1894. Musée du Louvre, Paris.
Half-sunken in a stony land sprawl naked waxen bodies; in their midst a workman lies inert. Across the sky passes a fierce child, mounted on a long black charger – War.

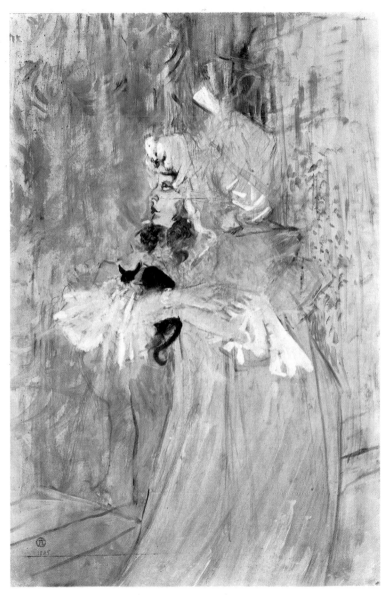

80 *Henri de Toulouse-Lautrec (1864–1901) : Miss Mary Belfort.*
1895. Private Collection, Paris.

149

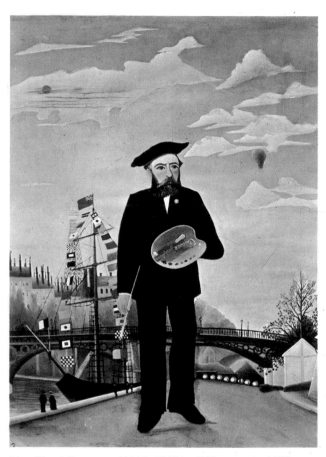

81 *Henri Rousseau (1844–1910) : Self-portrait. 1890.*
Narodni Gallery, Prague.

82 *Henri Rousseau (1844–1910) : The anglers. 1907–8. Musée du Louvre, Paris.*

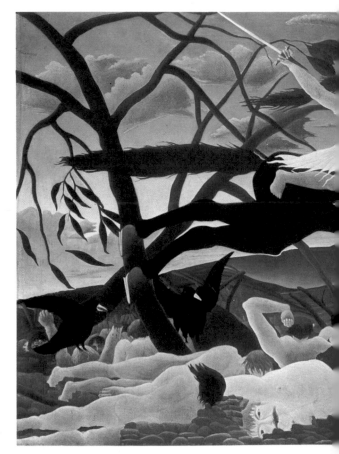

83 *Henri*
Rousseau
(1844–1910):
War or the
cavalcade of
discord. 1894.
Musée du Louvre,
Paris.

153

and luxuriant forests possess the same consistency of innocent fantasy to which some provincial simpleton dreaming of fabulous lands might abandon himself. After many years of being misunderstood, Rousseau was 'discovered' by the critics towards the end of his life and thus witnessed an unhoped-for success that was confirmed and consolidated after his death.

BIBLIOGRAPHY

G. BATAILLE, Manet, New York 1955

G. BAZIN, French Impressionists in the Louvre, New York 1958

C. BELL, French Impressionists, New York 1952

J. DE BEUCKEN, Cézanne, A Pictorial Biography, New York 1961 g. b

G. BOUDAILLES, Gauguin : His Life and Work, New York 1966

A. CHATELET, Impressionist Painting, New York 1962

F. ELGAR, Cézanne, New York 1969

F. ELGAR, Van Gogh : A Study of His Life and work, New York 1958

F. FOSCA, Degas, New York 1954

F. FOSCA, Renoir, New York 1970

W. GAUNT, Impressionism : A Visual History, London and New York 1970

E. JULIEN, Toulouse-Lautrec, New York 1959

P. POOL, Impressionism, New York 1967

J. REWALD, Gauguin, New York 1970

M. ROSKILL, Van Gogh, Gauguin and the Impressionist Circle, New York 1970

A. WERNER, Post Impressionist Painting, New York 1964

INDEX OF ILLUSTRATIONS

157